The Way Things Go

The Way Things Go

An Essay on the Matter of
Second Modernism

AARON JAFFE

UNIVERSITY OF MINNESOTA PRESS

MINNEAPOLIS · LONDON

Frontispiece: "Noveltywaste." Illustration by Patrick L. Odom, www.patrick-odom.com. Copyright Aaron Jaffe.

Portions of *The Way Things Go* have been previously published as "Nothing Risked, Nothing Gained: Richard Powers' Gain and the Horizon of Risk," *Transatlantica* 2 (2009): http://transatlantica.revues.org/4632 and as "Modernist Novelty," *Affirmations: Of the Modern* 1, no. 1 (2013): 105–38.

"The Instruction Manual," by John Ashbery, from *Some Trees* in John Ashbery, *The Mooring of Starting Out: The First Five Books of Poetry* (Hopewell, N.J.: Ecco Press, 1997), 8. Reprinted by permission of Georges Borchardt, Inc., on behalf of the author.

"Brancusi's Golden Bird" was published in Mina Loy, *The Lost Lunar Baedeker* (New York: Farrar, Straus and Giroux, 1997), 79–80. Reprinted by permission of Roger L. Conover.

"At Melville's Tomb" was published in Hart Crane, *The Complete Poems and Selected Letters and Prose of Hart Crane,* ed. Brom Weber (New York: Anchor, 1966), 34. Copyright 1933, 1958, 1966 by Liveright Publishing Corporation; copyright 1952 by Brom Weber; reprinted by permission of Liveright Publishing Corporation.

Published by the University of Minnesota Press
111 Third Avenue South, Suite 290
Minneapolis, MN 55401–2520
http://www.upress.umn.edu

Library of Congress Cataloging-in-Publication Data

Jaffe, Aaron.
 The way things go : an essay on the matter of second modernism / Aaron Jaffe.
 Includes bibliographical references and index.
 ISBN 978-0-8166-9201-9 (hc : alk. paper) — ISBN 978-0-8166-9203-3 (pb : alk. paper)
1. Civilization, Modern. I. Title.
 CB357.J34 2014
 909.8—dc23

 2014001557

Printed in the United States of America on acid-free paper

The University of Minnesota is an equal-opportunity educator and employer.

20 19 18 17 16 15 14 10 9 8 7 6 5 4 3 2 1

How the hell do I know why there were Nazis? I don't know how the can
opener works.

 —Woody Allen, *Hannah and Her Sisters*

We are perhaps the last generation to be able to see the way things are
going.

 —Vilém Flusser, *The Shape of Things*

CONTENTS

Instruction Manual

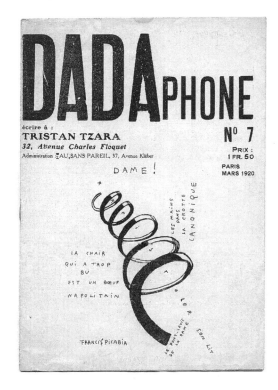

FIGURE 1.
Dadaphone—Francis
Picabia, Cover of
Dadaphone 7
(March 1920)

Everything we see hides another thing.

—René Magritte

Congratulations.
You're the proud owner of this book.
Now what?

Having gotten this far, you've already mastered the basics. The ground rules of the codex are, for the time being, still perfectly familiar: leaves of paper, bound and boxed together; one thing after another; page by page; word by word. *Japonica / Glistens like coral in all of the neighboring gardens,* but, to-day, we have the naming of parts.[1] Pay attention; you might learn something. The size—the book's heft—points to something about the time it takes to read it.[2] Start to finish, this book is designed to be handled by a reasonably adept book user like yourself, who can put down a few dozen pages per day, in about four days. Find some Raymond Scott.[3] Read at your leisure. Keep going. Get to the end.

The Way Things Go is about the explosive capacities that reside in what seems like the inanimate matter of modernity. After this part, there are 100 sections—#100 counts down to #1—for a century of technical interruptions, knocks, bangs, misfires, props, novelties, waste products, found objects, chance encounters, potential hazards coming down the road and receding in the rearview mirror. As the book becomes a waste product, it malfunctions; dead ends and remainders call for redundancies, and gear squeals, more forgiving tolerances. The critical action begins with maximum input—potential energy ratcheted up to #100 with far too much to say, and from there running down entropically through a series of states ready-made for controlled epistemocritical collapse. #100 to #1 leads from cultural theory about things (#99) to the archaeology of pranks (#61), through literary theory (#37) to art criticism (#15), toward quiescent stasis. The following manual on manuals is also a user guide to the concepts that overlap or collide in this book.

Beginning a book with a manual—a manual for a book in lieu of an introduction—seems no doubt like a gimmick to you. The status of gimmicks is one key issue in *The Way Things Go*—how modernity gets caught up in a particular magic trick (*gimmick, magic*—the etymology points suggestively to an anagram) concerning novelty and waste. It was the French symbolist poet Stéphane Mallarmé who envisioned the book as a perpetual novelty item disclosing nothing less fantastic than "all relations between everything" (des relations entre tout).[4] Everything in the world exists in order to end up in a book, Mallarmé writes (tout, au monde, existe pour aboutir à un livre).[5] Of course, whatever Susan Sontag said about photography, it's the online wasteland that makes the

most sense of Mallarmé's idea these days. Everything in the world exists in order to end up on the Internet.[6]

But, an instruction manual—tossed in a drawer or in a glove compartment, always supplemental to the thing itself—already lays waste to the ambitions of the self-sufficient book. The manual serves out its duty as a book of last resort, the one never read cover to cover (except by "mutants," according to one historian of the genre), only referenced once the thing itself breaks down.[7] The word *manual* comes, of course, from the word for hand, and it's handy somehow to introduce this book—the last part I wrote, the first part you read—with the concept of a handbook for a book. Mallarmé's dream of the omnipotent and ubiquitous book occurred in an age when the book was still necessary equipment. As books start to malfunction, some things become more noticeable about their form.

This brings us to our first novelty item: a page recently found circulating on the Internet, scanned from the stand-up comedian Demetri Martin's *This Is a Book*, making this same point about manuals and books: "If you're reading this sentence then you've pretty much got it. Good job. Just keep going the way you are. (Please ignore this part)."[8] If you're reading *this* sentence, of course, you've pretty much mastered the book as design. (The gag depends on a sense that there's something amiss about books nowadays, that books aren't as self-evident as they used to be.) A fragment of printed matter encountered in the *mise-en-abyme* of "comments" and cascading marketing tie-ins—among the trolls, flame wars, and lolcats—resembles something of uncertain provenance and usability, akin more to waste produced by malfunction than anything else. Or, perhaps, the book is a relic such as a buggy horsewhip, a phrenological instrument, or a hammered dulcimer? Is attachment to printed matter now "a sentimental archaism, like preferring candles to electric light or hansom cabs to aeroplanes," as George Orwell already described such melancholic affections in his day?[9] Even before the Internet began dismantling the book in real time, Italo Calvino pronounced on this situation: "You are about to begin reading Italo Calvino's new novel, *If on a winter's night a traveler*. Relax. Concentrate. Dispel every other thought. Let the world around you fade. Best to close the door; the TV is always on in the next room. Tell the others right away, 'No,

How to Read
This Book

If you're reading this sentence then you've pretty much got it.
Good job. Just keep going the way you are.

(Please ignore this part)

FIGURE 2. Malfunctioning book—Demetri Martin, *This Is a Book* (New York: Hachette, 2011), xv.

I don't want to watch TV!' Raise your voice—they won't hear you otherwise—'I'm reading! I don't want to be disturbed!' Maybe they haven't heard you, with all that racket; speak louder, yell: 'I'm beginning to read Italo Calvino's new novel!' Or if you prefer, don't say anything; just hope they'll leave you alone."[10] Given all the new distractions, who can blame a book these days for requiring a manual?

With its deliberate subservience to things outside itself, a manual not only profanes the notion of an autotelic book but also tells us something about its last days. John Ashbery's poem "The Instruction Manual" pits mutant manual writing "on the uses of a new metal" against a procrastinating poet's daydreams with surprising effects:

> And, as my way is, I begin to dream, resting my elbows on the desk and
> leaning out of the window a little,
> Of dim Guadalajara! City of rose-colored flowers!
> City I wanted most to see, and most did not see, in Mexico!
> But I fancy I see, under the press of having to write the instruction
> manual,
> Your public square, city, with its elaborate little bandstand![11]

Strange poetic alchemies reside in manuals.[12] Against all odds, if squeezed very hard, its machinery, like Baudelaire's juicer of old oranges, might press out an *ars poetica*. A DOS manual already seems more antique, more marvelous, than Chaucer (sitting on a table at the graduate student book sale, for instance), but it's Chaucer's own incomplete *Treatise on the Astrolabe* (1391) that captures the genre's classic disposition. Note that the astrolabe is more arcane in Chaucer's time than ours—not because of its relative importance for navigating or surveying, but because the knowledge needed to operate one (and the kind of information it generates) is less available in Chaucer's time than ours.[13] The addressee is a technological initiate, *homo ludens* not *homo faber*, a player, inserted at halftime in a communicative game with his occulted technical possession. To unlock the secret operations of this complex time-and-space instrument, the manual addresses Chaucer's young son, little Lewis, who has demonstrated some aptitude in mathematics ("sciencez touchinge noumbres & proporciouns"). In effect, Lewis, who didn't write anything

FIGURE 3. The "Chaucer" Astrolabe (1326)—The British Museum, Copyright Trustees of the British Museum.

(and may be fictional), is the first child of technical modernity, because he's addressed lovingly by a manual.[14]

The elements of manual style are already in place: most notably, the conspicuously absent promise of technical mastery. Make no mistake, existing accounts are glitchy, and exposition will be redundant by design: "betre to writen vn-to a child twies a good sentence, than he for-get it ones." Modernity's child is addressed tenderly but partially—affectionately positioned before a tool presented as a toy: "Thyn Astrolabie hath a ring to putten on the thombe of thi right hond in taking the height of thinges." Centuries before owners become users—and before manuals include statements in tiny fonts about lease-holding rights and manufacturer indemnity—a particular technical disposition gets hardwired in. The manual is "a recreation of a recreation," to borrow a formula from Izaak Walton's *Compleat Angler* (1653), a second look back at the thing, accessed a second time from the vantage of bemusement: "If this

Discourse which follows shall come to a second impression, which is possible, for slight books have been in this Age observed to have that fortune; I shall then for thy sake be glad to correct what is faulty, or by a conference with any to explain or enlarge what is defective: but for this time I have neither a willingness nor leasure to say more, then wish thee a rainy evening to read this book in."[15] Walton's manual, like Chaucer's, defines itself by a certain friendly relation, care, extended even to frog-bait, as it happens: "Put your hook, I mean the arming wyer through his mouth, and out at his gills, and then with a fine needle and silk sow the upper part of his legg with onely one stitch to the arming wire of your hook, or tie the frogs leg above the upper joynt to the armed wire, and in so doing, use him as though you loved him, that is, harm him as little as you may possibly, that he may live the longer."[16] Handle it with care, says the handbook. The first step is to make friends. Without anachronism or invented antecedents, disparate things get linked in common communicative cause. The appeals of astrolabes and frog-bait are predicated on an approach to technical knowledge that emphasizes affection for the nonhuman thing over systematic classification.

By the mid-nineteenth century, non-experts were hooked on complex mass-produced items—firearms, pocket watches, table-top printing presses, sewing machines, indoor plumbing—the manuals for which advanced pleas about taking care with inanimate things on a massive scale. A peculiar epistemological interzone emerges, apart from the technical discourse of technicians, manufacturers, and mechanics, that enshrines the rights of the ignorant in terms of their affections for things never quite understood. According to scholars of technical communications, the Singer sewing machine becomes the template for the modern manual by engaging the attentions of nontechnical users. In the twentieth century, the Model T manual conspicuously follows suit: "Nearly all Ford cars are driven by laymen—by owners, who in the great majority of cases have little or no practical experience with things mechanical."[17] At the same time as it warns about "imitation, or bogus or counterfeit parts of inferior quality [being] made and sold as Ford parts," it frees users from the work of grasping much about the insides of things: "The simplicity of the Ford car and the ease with which it is operated renders

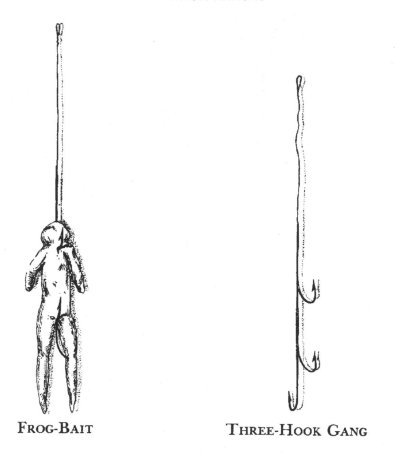

FROG-BAIT **THREE-HOOK GANG**

FIGURE 4. Frog-bait—Illustration from "Nessmuk," *Woodcraft* (1884, 1920) (New York: Dover, 1963), 41.

an intimate knowledge of mechanical technicalities unnecessary for its operation."[18] Such knowledge functions as a mainstay of a strange intimacy, an extimacy, cribbing one of Jacques Lacan's words, a means of fastening exteriors onto interiors: "The more one knows about a thing the more one enjoys it," so says the manual. Instead of knowing hidden secrets—how something is made or why it works—what's stressed is knowing what a thing can do (for you).[19] It comes as no surprise, then, that early computer manuals were deliberately modeled on the same automotive manuals, which had in turn retailored the strategies of sewing machine handbooks.[20]

Thinking of sewing machines and their paraphernalia, recall that a sewing spool plays a critical role in *Beyond the Pleasure Principle* (1920), when Freud discusses the case of a small boy—his grandson, in fact—who habitually trashes his bedroom.[21] Everything that isn't nailed down ends up on the floor, thrown in the corner, under the bed, and so forth, much to the consternation of his minders. The ejecta include not only his toys, but all kinds of sundry matter—a binkie presumably, slippers, a comb, a brush, a bowl full of mush, and so on.[22] Yet, despite his general propensity to scatter things, this child also has a peculiar attachment to one whirligig in particular, a wooden spool attached to a string. Each time the spool is thrown away, it can be retrieved. And, as the ersatz yo-yo is worked back and forth, the child repeatedly intones the same excited exclamations: something like "Go away!" (or, *fort!*) when it disappears and "There it is!" (or, *da!*) when it rematerializes. The interpretation of

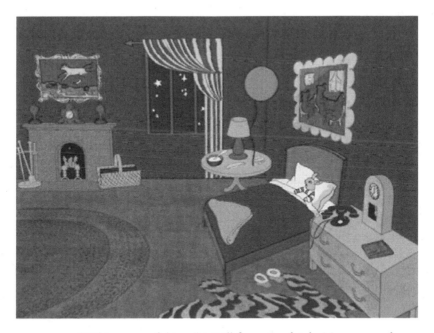

FIGURE 5. "Taking care of things"—Still from *Goodnight Moon . . . and More Great Bedtime Stories*, DVD (Scholastic Inc., 2011); adapted from Margaret Wise Brown and Clement Hurd, *Goodnight Moon* (New York: Harper and Row, 1947). [See endnote 22.]

the game, Freud says, is closely tied to it, and tied specifically to the child's utterances. In the game, the spool both *never was* and yet is also *perpetually* available, as if by magical command.

According to Freud, the thing—and the rest of the lost property, for that matter—designates the inexorable disappearance of the mother from the cribside. The *fort/da* game helps the boy come to terms with the inevitable loss of the mother by mastering her in a miniature form within his headspace. Without rejecting Freud's interpretive acuity— let's bracket the subjective associations he adduces, the self-evident symbolism that connects a sewing spool with the maternal, and a crib with infantile dominion—the idea, then, is not so much to consider what it feels like to be a spool, that is, the "perspective" of the nonsensible, as to expose an even more fundamental backdrop of novelty and waste behind the subjective push and pull of object relations. In practice, the *fort/da* formula also means something like *"Get out of here!"* and *"Eureka!"* and these word-bubbles not only apply to spools and family members but also point to the general traffic of all things. With few exceptions, the fate of the vast number of things—everything that isn't nailed down, in fact—is dispersal. When it comes to the way things go, it's profoundly more difficult to find a novelty than to lose something in this vortex. Even tidying up, more often than not, stands for little more than hiding certain things from view, throwing them in some forsaken corner. Freud's quarrel with his grandson may follow from different standards of decluttering. The boy addresses objects only insofar as he casts them away from his zone of attention. When they return, he doesn't so much welcome their return ("Ahoy thing!") as proclaim their very existence, as if for the first time: "Eureka, a thing"!

So much commentary has been given to the boy's choice of labels that what's often missed is that the word Freud himself advances for all this other stuff, the scattered stuff, isn't *things* or *objects* but *matter* (*Gegenstände*).[23] The child sprays his room with all kinds of matter, disposing of it—or perhaps decommissioning it—into the miscellaneous backfill of lost property (*verlorene Gegenstände*). Whatever the subjective meaning of any particular thing, the critical detail I wish to underscore about the remaining jetsam is its uncountablility. Countability or uncountablility isn't an intrinsic property of stuff. Nor, I hasten to add,

FIGURE 6. Whirligig—James L. Haven and Charles Hettrick, Whirligig, U.S. Patent 59,745, issued November 20, 1866.

is it merely a symbolic association. Instead, countability is relational—numbering the parts in relation to the whole. Part of the outrage in this case—which is always modernity's case, too—is that there's too much to count, let alone to clean up. Indeed, it's the whole matter of the sum of all the uncountable junk that puts a spotlight on a single novelty. The boy's coping strategy comes first for Freud—a great cultural achievement, he calls it—but the sudden appearance of this novelty amid all the waste—the interruption of a message amid all the noise—also provides an enormous invitation to method, not least for Freud.

The method begins by losing the thing demonstratively—and then theatrically locating it, reeling it into the spotlight. Two operations, inexorably linked: novelty redeemed from waste, as if filmed in reverse motion. When Walter Benjamin writes in "Convolute N" of the *Arcades Project* that he has "nothing to say, only to show," he does so less to explain his own methods than to invoke something of a methodical incantation about modernity's offices of lost and found.[24] He likens his approach to literary montage, conceived of, quite explicitly, in terms of a user's manual for rescuing novelty from waste. Here, Benjamin is quite specific about what the procedure is not: it's not about picking stale chestnuts from the garbage can; nor pronouncing "sayings"; neither affirmative catchphrases nor looted valuables. The debris isn't even to be counted, he says. Instead, the debris—"the interruptive function of [its] naked non-signifying presence," in Rancière's words—is given its due merely by yielding to its right of way.[25] Indeed, Benjamin's dictum echoes a line by Picasso borrowed by Lacan in Seminar II: "I do not seek, I find." Where we might expect to find a statement of method, Lacan instead presents us with findings. What is curious, though, is that the claim itself—"I do not seek, I find"—discloses the very methodological reflection it professes to withhold.[26] By the time Lacan gets to Seminar 24, moreover, even "finding" is off the table: "Long ago, I happened to say, imitating a famous painter, 'I don't seek, I find.'"[27] Of course, there's more to such statements than merely the showy disavowal of method—how could there not be? Still, there's something of the conjuring trick in these inscrutable mottos. Don't find, don't seek, don't even tell: our eyes are directed elsewhere, thereby sustaining the master's sleight-of-hand. Such claims thus amount to something other than

a hermeneutic (or an object-oriented ontology). Rather than inducing us to heed the call of things from within the tangle of discourse that enshrouds them, these utterances instead comprise the magic words of methodological stagecraft, a theoretical version of welcome to the show, presto, hocus pocus, abracadabra.[28]

Like Michel Serres's idea of the joker—the white domino, which changes things by reversing the direction of play—one kind of novelty transmutes into another (*austauschbare Gegenstände*). From astrolabe to frog-lure to sewing machine to automobile to computer: these things progress not by the analogy but in their shared capacity for coming to rest at a particular distracted disposition. The famous backfiring automobile in *Mrs. Dalloway* engenders a lot of intersubjective traffic, but it leads neither Clarissa nor Septimus to pause over the object causing the interruption. It isn't their car, of course. If it were, they might want to know what a manual says: "When the engine knocks from any cause whatsoever, the matter should be promptly investigated by an experienced mechanic and the difficulty corrected." See answer No. 28: "There are several causes, which may be enumerated as follows: (1) carbon knock—which is by far the most common—resulting from carbonizing of cylinders; (2) knock caused by a too advanced spark; (3) connecting rod knock; (4) crank shaft main bearing knock; (5) knock due to loose-fitting piston or broken ring; (6) knock caused by the piston striking the cylinder head gasket."[29] A knock is a type of interruption, an event of evidently some mechanical import, that might generate a trip to a manual; a manual containing a kind of algorithm that recommends repairs; a set of steps for addressing a knock, an interruption, a shock, a pause, a hiccup.[30]

Likewise, pursuing a method of presentation that has nothing to say, only show, as Benjamin advocates, means preferring accidents, disruptions, and critical through-put to mediations or intersubjective traffic.[31] Circling the found object, taking notes on interruptions, staging illuminating crashes and juxtapositions, this book tries to fashion a critical method that resembles a kind of Rube Goldberg apparatus—to invoke the celebrated twentieth-century cartoonist and honorary Dadaist, whom we will encounter down the line (#84). Like one of his contraptions, it starts out with input, follows a defined rundown of successive steps, and

eventually terminates by presenting output. Formerly an engineer with the San Francisco City Water and Sewers Department, Goldberg clearly had patent diagrams, schematics, and manuals on his mind.

Take for example *Sending a Late Stayer Home*: At 1 AM, (A) the door of a cuckoo clock springs open, pulling (B) a string, fastened with a pulley to the trigger of (C) a gun, firing a bullet at (D) the emergent cuckoo, who then falls onto (E) a board, balanced on a sawhorse, flinging (F) a knife into (H) a suspended sandbag, (I) spilling it, onto (J) a balance scale, attached, again, by (K) a pulley, to (L) scissors, which cut (M) another string, that drops (N) a ceremonial mask, resembling a Klan hood, onto (O) the head of a tiresome houseguest, triggering a response from (P) a he-goat primed to buck when shown the relevant ceremonial paraphernalia, and thus unceremoniously ejecting the guest from the premises through an open window. Input : output :: the clock strikes one : the bore gets the boot. Circling the contraption, one notices multiple instances of frozen movement: ballistic trajectories projected forth with dotted lines, an anticipatory peek at sand dribbling from the bag, billowing smoke emitted from the guest's cigar, exploded views of the discharged cuckoo and rifle. None of these steps has yet "happened"—the diagram presents an anticipatory illustration, with taut strings unbroken,

FIGURE 7. Interruption Machine—Panel from Rube Goldberg, *Sending a Late Stayer Home*, circa 1930. Reprinted in Maynard Frank White, *Rube Goldberg Inventions* (New York: Simon and Schuster, 2000), 63.

the animal straining in the slips, and the guest, sitting next to his hat and coat, alert but unaware of his impending expulsion. These contraptions are more than the sum of their parts by design; they counsel us about the ambivalent yields that things bring for modernity and its communication systems. The adjectival *Rube Goldbergian* has come to mean something along these lines: "A device or scheme that achieves a simple objective by exaggeratedly or absurdly complex means; unnecessarily complicated, impracticable, or ingenious."[32] There's more going on, though. Rather than the familiar moral about the certainty of needless complexity, what's illustrated is a series of encounters in which costs and benefits are up for grabs. Who's to say, for instance, that all the *Rube Goldbergian* planning isn't worth the effort to show a self-important windbag to the curb?

The parts are simple, ordinary things *(alltägliche Gegenstände)*. The physics of each thing is, more or less, easily comprehended. Yet, each— the pulley, the scissors, the gun—conceals hidden potential energies: pulley loads already lifted, rifles loaded, goats fed and trained, theaters propped with sundry things (#68), and in each case human agency gets edited out. Goldberg's raw materials look harmless enough at first glance, but the abused animals and booby traps conceal explosive potential, explosive charges, which will go off when disturbed. Dean Snyder is right to say that this isn't the cyborg body per se with gearlike insides, like Fritz Kahn's *Der Mensch als Industriepalast* (1926), but human remnants directed to social ends, "people reminding you to take out the trash, mail a letter or the mother that cools off your food and dresses you for school etc."[33] The Goldberg invention is more like inhuman intelligence, the technically extended thinking and communication contraption described by the philosopher Andy Clark:

Consider the following scenario: You have to remember to buy a case of beer for a party. To jog your memory, you place an empty beer can on your front doormat. When next you leave the house, you trip over the can and recall your mission. You have thus used . . . a familiar trick . . . exploiting some aspect of the real world as a particular substitute for on-board memory.[34]

The scenario also happens to illustrate how found things enable communication by means of interruption.[35] The beer can provides the trigger and also indicates the endgame; most importantly, its being tripped over conveys a message of interruption that fastens the human being to a chain reaction that brackets out human hazards. The contraption is, above all, an inhuman problem-solving and teaching machine—in effect, an algorithm—that depends on a "fusion of metaphor" of "sensory devices, scanners, probes, vehicular forms collecting information, relay transmissions, detection instruments . . . all tasking away" in the name of the communicative destiny of humanity.[36]

Jovi Schnell points out a connection between the Goldbergian apparatus and an idea of higher learning, namely, the university itself as a "physical plant," "a unified hybrid organism, sprouting various truncations of specialized knowledge, crossbred in-formations branching off sporting new buds of thought. Simultaneously a body, machine, plant and universe. And full of a vigorous and mysterious energy."[37] The framing device of Professor Lucifer Gorgonzola Butts, Goldberg's amanuensis, lends some credence to this observation. Butts poses difficult word problems and then proposes engineered solutions—answers illustrated by carefully arranged things. In this way, the aesthetic algorithm plots a through line through a communication impasse about what things say and do. Bracketing out the human—editing out human effort—is both an answer to difficult problems and a means of achieving automatic, wordless messages.[38]

One point of my century-long contraption is to treat the number 100 not as a historical unit but as a kind of writing instrument. Before we completely forget the printed book—what the technology did, as it were—a countdown buffers it with a formal redundancy and a cross-referencing application that borrows from its technical rival. Keep going. Get to the end. The precise sense of an ending (#1) is a rebuke to the interminable, anonymous non-thing that happens when writing occurs online. The selection of the number 100 as a symbol is a by-product of a larger interest that cuts across the book about the relation between the twentieth century and modernity. My contention is that modernism is a particular scene for presenting aesthetic form and accounting for cultural value in the face of a situation in which there is no coherent

FIGURE 8. "Higher learning"—Jovi Schnell, *Untitled*, from Tree of Life series, 22.5 × 15 in., gouache and stamped collage on paper, 2005.

epistemological account of the whole. Modernity is not so much a packet of years as an epistemological condition that, as Nikolas Luhmann observes, "knows no positions from which society could be adequately described for others within society." In effect, modernity is a world in which everything is never the case, in which society "barely understands itself . . . so it marks its newness by relegating the old, thereby covering up its own embarrassment at not really knowing what is going on."[39]

The number 100 means that the novelty shop of the twentieth century is still open. Without fail, the twenty-first century comes up short before it can even roll out of the showroom. In this regard, the representative value of the twentieth as the first fully modern century has not expired—Alain Badiou echoes this point in his book called *The Century*. Unlike Badiou, who favors a short, very Soviet century—1917 to 1989—I take on a longer version here—starting from approximately now and tracking backward until sometime on or about 1900.[40] The critical ambition is to push the buffers of *the long now* backward.[41] The will to count—which Badiou, Maurice Blanchot, Patrik Ouředník, and so many others connect to the enormous number of victims in the last century, the *centuria* of living corpses unleashed by instrumental reason—might be productively countered with an injunction to count backward. The clock winds down; we sweep up debris. *Es ist nie zu spät für eine schöne Vergangenheit. Never give up on your desire for a better past.*[42] And, much of the last remaindered century is precisely about wasted books—Ezra Pound's few thousand battered books, Theodor Adorno's line about poetry after Auschwitz, the koan in W. H. Auden's elegy for W. B. Yeats—these images of rubbished books suggest that in all the accounting of the last century the culture of book was weighed in the scales and found wanting. The century countdown as writing lesson sharpens—and, adds a redundancy—to my point that novelty and waste rejiggers the meaning of now and then—it's argument by exposition and accumulation about the movements of things in modernity.

The concept of a *second* modernism (#36) is an effort to account for the pronounced difference between two interrelated meanings of *century*. *Secondness* here is less about chronology than reflexivity; the second release was implicit from the start. *First* modernism constitutes a present with a knowable past, *second* holds an unknowable future determinate

of the present. Therefore, this approach is necessarily more epistemo-critical than ontological, a certain if incomplete tool for retro-burdening the future—for defining future effects of the deep time of modernity.[43] Another fitting motto for this project might be: modernism, now or never. Or else: modernism, now and forever. The critical effort seeks to disclose modernism's idiosyncratic legacies across an impossibly long century spanning *two* potholed fins-de-siècles. "The two ends of the twentieth century hail each other like long lost twins," as Tim Gunning writes.[44] Modernism, I'd like to introduce you to . . . modernism, *mon semblable, mon frère.* The point, which Julian Murphet makes particularly well, is not merely to concoct a historical analogy between modernisms now and then. Rather, following Tom McCarthy's lead in *C,* it tries to find a century's worth of coherences concerning a future-overburdened past, echoes of the Internet already programmed on the radio, as it were: "The static's like the sound of thinking. Not of any single person thinking, nor even a group thinking, collectively. It's bigger than that, wider—and more direct. It's like the sound of thought itself, its hum and rush."[45] The countdown is a fitful launch backward into a bigger, wider, more direct modernity with uneven, unsettled, and unsettling consequences. The desperate gambler, feeling something auspicious coming in the last few hands, can't leave the table without making one last bet on Mallarmé's book dream. The book still has something lively and material to say to us. Doubling down on modernism, then, means channeling big-M and little-m modernism, as Catherine Driscoll usefully puts it: that is, big M, the auto-institutionalizing brand, the industry of proper names, anthologies, galleries, and museums, and little m, the expanded, generic contraption that takes on modernity in all its critical, interdisciplinary, transnational complexities, one zone of a Venn diagram shared with modernities philosophical and sociological.[46] As Owen Hatherley has recently made plain, little m has still got some service in it, a modernism fit to "respond to, attack or play games with."[47] The latest modernist resurgence is less a matter of conservative retrenchment away from postmodernism as it is evidence of continued mutations of cultural value occurring in modernity, and the unremitting need for continuously returning to the unfinished business of literary history and literary modernity.

What comes after postmodernism? As Murphet has argued, the strong form of postmodernism was all too aesthetically reductive, drinking too deeply from the well of then fashionable end-of-history thesis statements. Its potted versions, which became a PR machine for fashioning lists of aesthetic alternatives to Modernism, did not age well. After all the modernism/postmodernism double-entry bookkeeping, "the survival, the residue, the holdover, the archaic" that Jameson argues were finally evacuated by the postmodern turn yet return more acutely than ever. A retro-revenant thing continues to stalk the present. Modernism names, in effect, a struggle with an incomplete future-past, and postmodernism, by extension, designates a ceasefire that claimed there was no future left to experience. If postmodernism is a kind of blinking cursor of the eternal present, what Vilém Flusser calls the non-thing (#81), a form of pluralist nihilism, the modernist revenant is a void in all this interminable plentitude. "Alle Apparate ausschalten," to crib Kittler's last words.[48] Not only is the idea of modernity's completion premature (because who knows, right?), but its expressive cultural immanence never quite made sense. Lots of people did not know the theory. Modernism, as the putative cultural logic of modernity, looks nothing like a positivist boosterism about either global markets or metanarratives as some described it. Rather, it resembles an apparatus for creative destruction, reinventing and reinvesting archaic survivals, resetting the clocks, reversing the eddies of now and then, inverting centers and edges, repurposing what's cheap and diminishing what's dear, "mutual and reciprocal determination between new and old" to the end of the Earth.[49] For Murphet, modernism names an "aesthetic expression of the uneven development between manual and mechanical media." The avant-garde, he writes, is "the most perspicacious scribe" of relations between media. Again, one thinks of McCarthy's ecstatic static or Serres's idea of the chattering parasite (#81, #66). Film celluloid, vinyl, radio transmission stand for a techno-medial revenant, retro-burdening the conceptual drive toward futurity. In Murphet's account, postmodernism designates a situation in which markets ("the infinitely larger and unrepresentable horizon of the mode of production itself") become aesthetically expressible as pure form, a techno-determinant qua absolute. Gertrude Stein theorizes "what a commodity might feel like if you ask it, stranded somewhere between exchange and

use," whereas Marcel Duchamp posits no daylight between the commodity and the artwork. In short, little-m modernism, in this release, ingests postmodernism without digesting it, yielding an aesthetic-affective interface with modernity ("critical, conformist, undecidably both") that takes on the contradictions and makes the ambivalences matter.

Okay, then, you might ask, *is this a theory-book or a modernism-book?* What it's *not* is a book in which "theory" is applied to "modernism" as if squirted from an ointment tube. Instead, the book investigates a certain co-articulation of "theory-modernism" as a kind of *Denkbild* akin to the duck-rabbit of Ludwig Wittgenstein's *Philosophical Investigations*:

> Should I say: "The picture-rabbit and the picture-duck look just the same"?! Something militates against that—But can't I say: they look just the same, namely like this—and now I produce the ambiguous drawing. (The draft of water, the draft of a treaty.) But if I now wanted to offer reasons against this way of putting things—what would I have to say? That one sees the picture differently each time, if it is now a duck and now a rabbit—or, that what is the beak in the duck is the ears in the rabbit, etc.[50]

Modernism—the first release, that is—usually gets "pictured" either as a period or as a style. The former holds that modernism is over—having begun with this, concluded with that; the latter suggests that it's contained—including this, excluding that. Neither makes much sense of the plenitude of modernity's background noise and the systemic uncertainties that it continues to introduce. Instead of trying to picture either *this rabbit* or *that duck*, *The Way Things Go* proposes that "modernism" might be best understood as a case of *both/and*. Understood as an ongoing, semiotically overburdened, uncertain market for the future cultural value of modern things, *second modernism* does thinking for us.

Buffed up to a metallic shine; loose-fitting, lopsided, or kludgy; getting in the way or getting lost; collapsing in an explosion of dust caught on warehouse CCTV: modern things are going their own ways and have been doing so for a while now. This book tries to follow their potential and kinetic energies. A course of thought about their comings and goings and cascading side-effects, *The Way Things Go* offers a thesis—a governor

FIGURE 9.
Duck-rabbit—"Do you
see a duck a rabbit, or
either?" Image from
Joseph Jastrow, "The
Mind's Eye," *Appleton's*
Popular Science Monthly
54 (1899): 312.

for the contraption: modernist critical theory and aesthetic method are
bound up with the inhuman fate of things as novelty becoming waste.
Things are seldom at rest. Far more often they're going their ways, enter-
ing and exiting our zones of attention, interest, and affection. What's
more, in its classic form, the modern thing may be going away. It is
actually, to use Flusser's word, a non-thing, and the modernist injunc-
tion to defamiliarize it *(to make it new)* is but a futile attempt to halt the
inevitable regress. To this end, the concern is less with a humanist story
of such things—in offering anthropomorphizing narratives about recoup-
ing the stuff we use—as it is with the seemingly inscrutable, inhuman
capacities of things for co-articulation and coherence. It looks at the
tension between this inscrutability, on the one hand, and the ways things
seem ready-made for understanding, on the other hand, by means of
exposition, thing- and word-play, conceptual art, essayism, autopoiesis,
and prop comedy. The book demonstrates that literary criticism is the
mode of analysis that can unpack this thing that at first glance seems
nonliterary. Furthermore, it comments on how the printed book itself
gets tangled in modern concerns about novelty and waste.

The Way Things Go is parted out in four sections. First, it explores the
proposition that modernity is synonymous with modern things tempo-
rarily standing out like so many props on the historical stage (#80).
Second, it considers the role of novelty and waste in the movements of
things, the leading edge and the back end of our interests and affections
(#61). Third, it examines how risk gets smuggled on board this process.
Modernity's thing culture is the hand in the glove of an uncertain "risk"

epistemology (#37). Fourth, it examines how and why this vexed and vexing materialism carries an associational logic that provides a remarkable invitation to thought, theory, and invention (#15). These sections are guided by Walter Benjamin, Charles Baudelaire, Ulrich Beck, and Joseph Beuys, respectively, who provide decisive leads into novelty, waste, matériel, and material. Like jewels hidden in a watch mechanism, the literary critic, the modern poet, the social theorist, and the conceptual artist play functional—as opposed to ornamental—roles in the chain reaction. Each seeks to bridge contemporary "theory" with earlier forms of poet-criticism so as to bring into view the relevance of an actual theoretical vernacular concerning the way things go. Modern prose, as Francis Ponge reveals, can be specially tuned to channel the poetry of the thing. *The Way Things Go* is written with this in mind. When Pound mentions Ford Madox Ford's lesson that poetry must be as well written as prose, the aptness of his remark owes as much to observations by Marx and Freud (about commodities and fetishes) as it does to the examples of Flaubert and James (about *le mot juste* and the direct treatment of the thing). If contemporary poetic concerns have been made more prosaic—Prufrock's trousers instead of the White Goddess's hem—the poet-critic must face up to the possibility that the thick letter of expositive prose may constitute a best practice for unpacking and sorting through the empire of things. Whether in poetry or prose, modernist texts are forever complicating these generic frontiers. They lead, I argue, to the door that C. K. Ogden comes to when he introduces Wittgenstein's *Tractatus* by noting the peculiar literary character of the whole, or the style of philosophy that Alain Badiou describes as adventures in the concept, a style for displacing preoccupations with vital interiorities with an expositive urgency for invention and waste management.[51]

Among other novelties and detritus, *The Way Things Go* delves into books, can openers, cars, roller skates, fat, felt, soap, books, joy buzzers, hobby horses, magic rabbits, felt erasers, sleds, kickstands, water bottles, and urinals. But it pursues them in the manner of typology and topology, chasing after a particular thesis that much of the recent aftertastes of things comes not from the isolated thing but from our movements along the inhuman interface of two types of non-things, novelty and

trash. There has been a flood of thing-talk from academic and nonaca-demic quarters during the last decade. Much of it has trained the heat lamps on the particularity of vernacular objects: apricot cocktails, coffee beans, dashboards, popsicle sticks, Barbies. And rightly so: such studies resist essentializing every thing into a commodity or a fetish, attending instead to their vital phenomenological qualities. This notwithstanding, *The Way Things Go* rebukes those romantic tendencies caught up in the pathetic nature of debris defining this conversation.[52] Instead of sweeping up the dust bunnies left over by thing theory—aka, the scholarly turn to poetic materialism—*The Way Things Go* seeks to explore how heteroclite wholesale projects of conceptual and disciplinary invention—the essayistic, the expositive, the conceptual, the speculative, the diffi-cult, the "Continental" thing—have a decidedly modernist genealogy.

The crass quantity of raw stuff often appears to undermine any poten-tial for subtlety or intimacy. Searching for any new good things in a technically unmediated way becomes a time-consuming chore. As Nova-lis puts it, "We look for the absolute everywhere, and find mere things" (Wir suchen überall das Unbedingte, und finden immer nur Dinge). We're forever telling the story of stuff. It can't speak for itself, so it's nar-rated, supplied a make-believe shorthand of life stories and feelings, biographies, and CVs (#21). Avoiding this critical trap *The Way Things Go* aims to expand, diversify, and sharpen the theoretical frames of interdisciplinary cultural theory. It proceeds with a hypothesis that the-oretical thinking and writing about good and bad things is not only a project with modernist preoccupations and orientations—it is also a project with modernist histories caught up in modernist fables about the ways things go. Yet, there is a tremendous amount of baggage on this score. The literary, critical, and philosophical lexicon is clotted with matter, things, objects, gear, artifacts, fetishes, commodities, utensils, property, props, equipment, and so on, words that flag different critical agendas. That this often rigid technical argot itself inevitably derived from a seemingly commonplace experience of the mutability of stuff gets at a sticky point about the meaning and value of matter in modernity.

Take the German word *Zeug* (#66). As a morpheme, it's found handily glued inside words like toy (*Spielzeug*) or tool (*Werkzeug*) or ordnance/explosive (*Feldzeugmaterial*) or vehicle (*Fahrzeug*) or writing materials

(*Schreibzeug*). In this way, it might be the most magnetic—or matter-bearing—among its rival German keywords (*Sache, Ding, Objekt*). "Pass me that *Zeug*" said in my kitchen refers to a tin of MSG. Witness how putative rivals Martin Heidegger and Walter Benjamin attempt to shave it down. For Heidegger, it designates the "purposive, referential status" of a utensil, an essentially useful thing, how a hammer refers to a nail, how a vehicle's turn-blinker indicates the direction of a turn, and so on—commonly translated as "equipment."[53] In Benjamin's less noticed use, the word conveys a peculiar remaindered association seen in superfluous stuff, junk, and props. Both cases, as Samuel Weber has observed, emphasize the explosive, leave-taking, and transformative character of the root word, a connotation that registers a certain dynamism—the

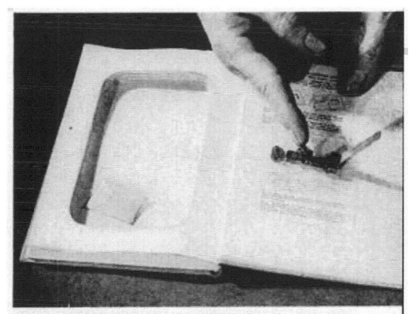

EXPLODING BOOK contains device to set off caps like those used in cap pistol. Pages are hollowed out to give the cap device room in which to operate.

FIGURE 10. Exploding books—Gardner Soule, "Fun's Henry Ford Is Still Inventing," *Popular Science* (January 1955), 125.

vehicular side of the way things go, in so many words. My interest in *Zeug* is in the way the term conceptualizes two seemingly opposed sides of things: not only their emergence as novelties, trinkets, or gimmicks but also their departure as waste, junk, or rubbish. "There is no explosion except a book," Mallarmé writes.[54]

Returning to vernacular, then, we take notice of a more physics friendly—and, less metaphysical—distinction between two kinds of *Zeuge*: devices and contraptions. Let's call one type of gear a *device* when its benefits are certain; it does work, multiplies or redirects effort, and so forth. A device is a thing made for a particular purpose; an invention or contrivance, especially a mechanical or electrical one. The classic example of this is the simple machine—the lever, the pulley, the wedge. When labor-saving capacities are uncertain, let's call that other type of gear a *contraption*. Insofar as we understand gear—not so much how it works or how its made but what it does—does gear increase or decrease our work? One of Heidegger's many esoteric points is that tools, when used correctly, seem to disappear (#47). The carpenter's hammer, like the mouse in my hand, becomes concealed in its proper, proficient use. In this way, Heidegger advocates a subtly inhuman form of humanism, for he notices the ways tools implicate humans in taking hold of their alien world. The ways things get hidden from us—get naturalized—can be a profoundly alienating experience. The work that goes into things—building them, the idea of alienated human labor, work condensed in commodities—might be another side of this, something disclosed not only when a thing malfunctions but also when the subject who uses it considers it.[55] Somewhat lost in Heidegger's account is that tool-getting, -making, and -using brings obvious unconcealed benefits—drawing on a technical understanding of *work* first proposed by Gustave Coriolis in 1828: work enables force multiplied by distance. A hammer's claw, for instance, the lever and fulcrum side of business, multiplies effort for extracting nails in certain, calculable ways. I'm never going back to the hammer-less alternative. Devices do work; in short, they multiply effort, they redirect or transfer forces, in ways that are patently beneficial. The technical-scientific name for this, *mechanical advantage*, is apt. The claw end of the hammer, for instance, doesn't just pluck a thing from the world of objects; it gives mechanical advantage. As Archimedes observes:

"Give me a place to stand and with a lever I will move the whole world." In contrast, contraptions do not so much move the world as they introduce ambivalent distractions and interruptions into the mix. The added benefits of calculator watches—or technological chimeras like smart phones, PowerPoint, or Facebook, for that matter—are uncertain: do they not introduce further complications into my work? The question speaks to the minimal difference between need-driven technology and technology-driven needs operating in our media system.

Wearing slippers with no-slip soles and a bee-jar shaped helmet, the Martian sits among poppies and fluttering moths on a pile of dead media: CDs and DVDs, cell phones, e-readers, broken keyboards, book readers, iPods. The City lies beyond in ruins, covered in lichen. The

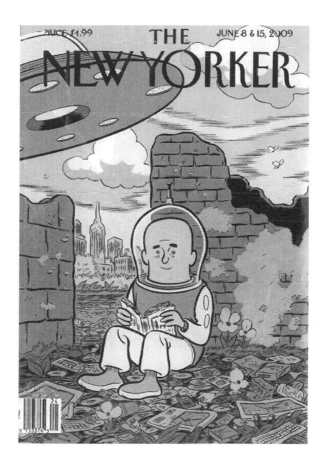

FIGURE II.
"Quiet, I'm
Reading. . . .";
Dan Clowes, cover
of *The New Yorker*,
June 8 and 15, 2009.

most famous of Craig Raine's Martian poems, "A Martian Sends a Post-card Home," crash lands on timely questions concerning the broken status of books:

"A Martian Sends a Postcard Home"

Caxtons are mechanical birds with many wings
and some are treasured for their markings–
they cause the eyes to melt
or the body to shriek without pain.
I have never seen one fly, but
sometimes they perch on the hand.
Mist is when the sky is tired of flight
and rests its soft machine on ground :
then the world is dim and bookish
like engravings under tissue paper.
Rain is when the earth is television.
It has the property of making colours darker.
Model T is a room with the lock inside–
a key is turned to free the world
for movement, so quick there is a film
to watch for anything missed.
But time is tied to the wrist
or kept in a box, ticking with impatience.
In homes, a haunted apparatus sleeps,
that snores when you pick it up.
If the ghost cries, they carry it
to their lips and soothe it to sleep
with sounds. And yet, they wake it up
deliberately, by tickling with a finger.
Only the young are allowed to suffer
openly. Adults go to a punishment room
with water but nothing to eat.
They lock the door and suffer the noises
alone. No one is exempt
and everyone's pain has a different smell.
At night when all the colours die,

they hide themselves in pairs
and read about themselves–
in colour, with their eyelids shut.[56]

The poem lays out a sequence of riddles concerning a number of "every-day" objects—objects that variously resemble natural, psychic, or "supernatural" phenomena. Books are like birds; weather is like books, or . . . television; so is being asleep; Model Ts are like rooms or . . . better, cinemas; watches, toilets, and telephones entail their own media phantasmagoria. As more than one critic has noted, there's something off about the Martian's epistemology, a kind of object-oriented amnesia. We may ask, with Michael Hulse, "how an alien familiar with engravings and television, the names Caxton and Model T, and so on, comes to be so stupid about other things."[57] Indeed, the ultimate puzzle in the postcard-like poem may be why the space invader is using snail mail. Given our just-completed tour of the genre, it's tempting to read the poem as a defective user's manual for a communication contraption—a smart phone, perhaps. If nothing else, the collection of referents, allusions, and associations illustrates what Serres and his interlocutors mean by quasi-objects, "entities" that are material but also conceptual, heterogeneous, and difficult to classify: references to the riddles of the Exeter Book and the printer William Caxton; birds, mist and rain; the Model T; television, telephones, and movies; indoor plumbing; tickling, smelling, and dreaming; an allusion to William S. Burroughs's novel *The Soft Machine*; rear-view mirrors; and the Earth. On second look, the program is oriented around three particular kinds of quasi-things: (1) atmospheric phenomena like mist and rain; (2) technological dispositions, including encounters with cars and toilets but preeminently with communication technologies; and (3) qualia, what "we" see or feel as colors, pain, or dreams. All these elements, like "London fog," "microbes," or "ozone holes," have both hard and soft implications, and, for the Martian at least, they all demonstrate uncanny communicative properties.

The status of books in all of this is a big deal. They are the most alienated of the alien's artifacts. Shipwrecked on a sofa fiddling with a damaged remote, the Martian communicates by *becoming media* in its most banal form—to borrow Murphet's phrase. Or, to transform his Kittlerian insight

slightly, the Martian channels a metaphoric repertoire of *unbecoming media,* the way media reorients things *after* books by retro-burdening our affective responses. *Pace* Lovecraft, this is *the color out of space.* The so-called intuitive aspects of new communication tech, grasped through the iconography of writing instruments and printed matter—pages, books, clipboards, desktops, erasers, and so forth—merely draw reference from habitual accommodation to the wasted things that we continue to stumble upon long after their novelty has expired. The bulk of the metaphorical devices, which come in couplet three-packs in the poem, are reverse engineered from communications technology, with broadcast television serving as the controlling malfeasance, the "ground" isolating all the other things from any ontological stakes in bookishness. *It's the televisual, stupid,* the sly, if admittedly lame, crib on the reference to Burroughs: "Nothing exists until or unless it is observed. An artist is making something exist by observing it. And his hope for other people is that they will also make it exist by observing it."[58] Significantly, this isn't the same old version of defamiliarization familiar from Viktor Shklovsky, who first fingered the key modernist aesthetic in "Art as Device" in 1917.[59] Raine claims to have never heard of the Russian formalist anyway, noting in an interview that it's defamiliarization itself that's now too familiar.[60] Nowadays, he says, "vivid imagery is perceived not as an illumination of the object but as an obstacle placed in front of it," as if describing a flower pot placed in front of a screen: "Ignorance, the mere absence of knowledge, need not detain us. But pure ignorance is the condition to which Descartes aspires in the *Meditations.* It doesn't just happen. You have to work at it until it is second nature."[61] Ignorance and knowledge are resequenced here. The familiar recipe for modernist innovation—defamiliarizing the ordinary things—now provides a handy, batteries-included device for churning out hackneyed workshop poetry. *Write a first-person poem from the point of view of a nonhuman other (rat, cricket, lobster, frog, aspidistra, pocket-watch, plunger, engine knock, spool, odradek, etc).* Tellingly, the Martian's assignment doesn't lead to new images—or to trips back to the library.[62]

Rather than the adolescent subjectivism that seeks to bypass semiotic obstacles to get to the objects themselves—"an innocent or naive view of everyday objects"[63]—Martianism makes more sense as a garbage

machine designed for relentless techno-medial disruption and distraction. For all the supposed naiveté, the noncomprehended cuts to the quick of the simile logic that intrudes a third parasitic go-between beside "natural" innocence and "cultural" experience.[64] Modernity's critical machinery is relentless on this score, retrofitting second nature, hearing lake water lapping standing on roadways or pavements gray, and so forth. Pound's "In a Station of the Metro" is paradigmatic:

> The apparition of these faces in the crowd;
> Petals on a wet, black bough.[65]

The order of operations concerning comparison and reference, the superimposed experiential/perceptual sequence, is the key to the modernist riddle. Are faces in a crowd like tree blossoms? Or, vice versa: are blossoms on trees like faces? Only Pound's title provides a clue, the Paris Metro, the disrupting branded quasi-object, is what establishes the association: the brand is the formative static. Pound calls this maneuver a "form of super-position," and what's worth noticing is the gesture's profound ambivalence about the dominion of nature or culture. It matters little whether such association tracks back to the natural (tree blossoms) or the cultural (references to Japanese printmaking or verse forms—"in some other very old, very quiet civilisation, some one else might understand the significance"): the Metro was vegetal destiny to begin with, Hector Guimard's Art Nouveau ornament enchanting the subterranean transport network with its green tendrils.[66]

> A Martian in the Metro might run something like:
> The apparition of these faces in the crowd;
> tubes in a dusty, Bakelite box

The observant Martian, ignorant of how things work, is preternaturally schooled in what they radiate when things go from novelty to waste. His preferred communication vehicle, the retro-burdened postcard, that epitome of tourist paraphernalia, saying very little about strange weather and toilets, registers that the agency of the letter is garbage collection, that writing *has* a future because litter has a future. To solve the

Martian's riddle, in other words: read it inside out, not from things to words, or vice versa, but moving from quasi-things to the interruptions they precipitate. What the poem resembles is not so much a defective user's manual but another more Martian-friendly genre: the invasion handbook. As Serres notes in *The Parasite*: what sent the invaders scurrying away "was only a noise, but it was also a message, a bit of information producing panic: an interruption, a corruption, a rupture of information."[67] Confounded by ruined interfaces between insides and outsides, subjects and objects, nature and culture, humans and things, then, decoy messages and red herrings slip into the intercepted messages.[68]

The poem can be read as a perversely encrypted invasion manual. Like the dummy corpses of Operation Mincemeat, it's stuffed with all kinds of bogus signals over dead media that target *homo faber* for influence and control by means of disruption.[69] The chief clue is that all the riddles are posed in terms of the chatter of communicative media. Indeed, one of the many disorienting qualities of the poem is its deliberate rejiggering of the aesthetic roles of novelty and waste. The idea that the telephone is a haunted apparatus recalls a familiar historical notion about radio sets. Stage names like Caxton or Model T—words that have come to be, in effect, genericized things like Q-tips or iPods—become the very mechanisms for denaturalizing and thus making new the branded innovations they designate. Meanwhile, mechanical things like indoor plumbing or automobiles have hard and soft communicative destinies; central heating means that inkwells won't freeze; Edison's light allows shopping at night; standardized time means more time on the clock; and so on. Communication tech takes on a strange habitual character: iPods become the dreamwork of radios; the Internet is the televisual absolute; Google, Glass. In the interim, the ever-precarious techno-medial shift retro-burdens the future by means of a skeumorphic past, as if through a backward telescope of obsolescent media: the "intuitions" of faux wood-grain on desktops and TVs, or fake stitching on dashboards, or sewing machines shaped like animals, or icons of obsolete floppy disks, convey messages about residual habits of affection and care.[70] I take this to be the meaning of the down arrow on the floppy disk icon (or, as the case may be, the manila folder icon). The call to delete the "obsolete" icon—because computers now save everything—heralds a

shift from a writing-driven model, where saving is the exception and forgetting is the default, to a default situation in which nothing is forgotten but nothing is worth saving. As B. S. Johnson writes, new tech accelerates a trial of dead forms that plays out through rituals of purification:

> It is a fact of crucial significance in the history of the novel this century that James Joyce opened the first cinema in Dublin in 1909. Joyce saw very early on that film must usurp some of the prerogatives which until then had belonged almost exclusively to the novelist. Film could tell a story more directly, in less time and with more concrete detail than a novel; certain aspects of character could be more easily delineated and kept constantly before the audience (for example, physical characteristics like a limp, a scar, particular ugliness or beauty); no novelist's description of a battle squadron at sea in a gale could really hope to compete with that in a well-shot film; and why should anyone who simply wanted to be told a story spend all his spare time for a week or weeks reading a book when he could experience the same thing in a version in some ways superior at his local cinema in only one evening?[71]

FIGURE 12.
Save Button

The Way Things Go

I Don't Know about the
Coming Singularity

100

I don't know about the "coming singularity"—Ray Kurzweil's tipping point between humans and thing-machines—but 2014 is the year in which my students are behaving as if books were passé.[1] Better formulated, this tipping point rehearses once more the entanglement of two kinds of nonthings: trash and novelty. Suddenly, for example, books become nearly forgotten things, paleo-artifacts like LPs, wax cylinders, or magic lanterns, best left to hipsters and other juvenile contrarians. Self-assuredly toting new gadgets, students come back from their holidays as if they've emerged on the right side of progress. "See, you got your Austens, your Twains, and your Dickenses; it's just as good," someone remarks after class, showing off a pseudo-book in a mildly aggressive way. Here, it seems, is Flusser's non-thing itself, a novelty ready-loaded with all kinds of fair-use, slack, and un-edited stuff, fingertip-ready, if not quite fit for careful study. In H. G. Wells's *The Sleeper Awakes* (1899, 1910), the protagonist from the 1890s finds himself in a strange future unencumbered by books. There, he visits a quasi-library, where "there were no books, no newspapers, no writing materials," only "peculiar cylinders" coordinated to a decorator's scheme.[2] Accessing them blindly, he stumbles on content from the remote past, accidentally downloading multimedia versions of works by Wells's own contemporaries and rivals Joseph Conrad

and Henry James, works he never got to the first time around. In a sped-up spectacle of "reality viewed through an inverted opera glass and heard through a long tube," the Wellsian protagonist momentarily gets re-entranced. When the show's over, he's dazed and confused: "He sat staring at the blankness. He started and rubbed his eyes. He had been so absorbed in the latter-day substitute for a novel, that he awoke to the little green and white room with more than a touch of the surprise of his first awakening."[3] If something is voided when absorbing ersatz novels, maybe it's the expansive experience of dwelling amid bookishness. The clutter of content dissolved under sleek, alluring surfaces, what's rationalized away is prepossession of and by the literary as a careful form of slowing down. Afterward, when the non-thing disappears, only a slight sensation of diminished gratification lingers, the eternal return of a capsulated dose of pleasure, which Woody Allen's *Sleeper* (1973) cannily reworks as the Orgasmatron.[4]

99

The book is a *Trauerspielzeug,* a way to toy with mourning, and the Sleeper is the last one who seems to care.[5] One lesson of Wells is that anxieties about the inefficiencies of the book in the age of televisual gadgetry predate television itself.[6] Books are certainly containers for content, but—on a shelf, in the mind, as a codex, ready to hand—they present something more. They enable dilatory intimacy, persistent claims on attention that other media forms—radio, film, television, portable digital formats—threaten to obviate, surge over, or tidy away. In Wells's allegory of a coming communication breakdown between the future and the past, he flags a systematic amnesia mediated by technological change that both overvalues and undervalues content. For all the new efficiencies, content becomes further and further alienated from format, and whatever else it is, the ersatz thing is also a stalking horse for the further deprivations to come: the novel imagined as a Merchant-Ivory spectacle; content ownership reformulated in terms of limited access and performance rights; free, disposable news serving as a loss leader; and a multimodal non-thing that signals the final triumph of the technicians and administrators over the writers' guild.

98

We are living in times of tremendous anxieties about books. Chief among these concerns is their materiality. The anxiety about printed matter is sourced to the affront of matter itself. Mass, at rest: in carry-on bags on trips, in boxes on dollies, displayed like food on coffee tables and shelves, in libraries, moldering in dumpsters, real books are taking up too much space these days. To this end, we are now witnessing the dissociation of book sensibility—in real time, mediated by gadget sales—in the name of a specious ideology. The phony claim of the e-book, the ersatz book, is that it extracts the intangible benefits associated with books—information, energy, mind, spirit—from the encumbrances of matter. Somewhere behind this is the received idea that you are what you read. Finishing a book uses it up, makes it part of you. Once its information is extracted, all that remains is waste, the only part that can't be digested into that ultimate ersatz form, that is, you and your gadget. Ironically, the motivation to decommission the physical form emerges from an ideology of the book itself. And, as if to make good on its own form of romantic idealism, the e-book (the book-as-spirit, the perpetual novelty) takes flight, eager to arrive at its beach vacation, and before takeoff, it eagerly chucks the other book (the book-as-matter, the shorn-off waste) into the security bin with the half-filled water bottles. Would it were true. There is still a lingering sense it was the heft and drag that counted in the first place. All those second thoughts about replacing editions with ersatz copies are reservations for the haptic side of things. With e-books, no more of this: "I am unpacking my library. Yes, I am. The books are not yet on the shelves, not yet touched by the mild boredom of order. I cannot march up and down their ranks to pass them in review before a friendly audience." With e-books, no more pursuits of books. And, when you find your way back to them—because who exhausts books?—will you become lost, unable to find your way to the somewhere just there you half-remember? The ersatz book may not linger around, reminding you to pick it up, nagging for proper attention, annotation, collection, display, or rereading. It may go to the auto-da-fé all too quietly, too exhausted to utter, "Father, can't you see I'm burning?" Unpacking his library, Walter Benjamin writes that having our books around counsels

us about how it was only our habituation to certain found things that
rescued us from chaos: what are your books "but a disorder to which
habit has accommodated itself to such an extent that it can appear as
order?"[7]

97

Zang Ho Hum. Scale and direction are the two factors affecting the way
things go in second modernity. The scalar and vector conditions of things
often feel to modern observers as matters of speed and vulgarity alone.
They don't see the things they're riding in. The crass quantity of raw
data, its sheer ubiquity, appears to undermine the potential for subtly or
intimacy. Searching for any new good thing in a technically unmediated
way becomes a time-consuming chore. Numinosity dims luminosity. In
The Speed Handbook, Enda Duffy approvingly cites Aldous Huxley's
assertion from the beginning of the last century that speed is moderni-
ty's only new pleasure.[8] G. K. Chesterton said something similar about
vulgarity: "Vulgarity is one of the great new modern inventions; like the
telephone or the wireless set."[9] Even if speed is twinned with vulgarity
in Marinetti's crashed Fiat ("like a vast shark that had run aground"), the
Vorticists, to take one example, were not so keen on what they called

FIGURE 13. Marinetti in his Fiat, 1909.

Automobilism. In *BLAST*, for example, the Vorticists pronounce Marinetti's Futurism merely a new strain of impressionist blur, ramped up and operated by Nietzschean posers and stuntmen:

> We don't want to go about making a hullo-bullo about motor cars, anymore than about knives and forks, elephants or gas-pipes.
> Elephants are VERY BIG. Motor cars go quickly.
> Wilde gushed twenty years ago about the beauty of machinery.[10]

A hundred or so years on, it is worth pausing again over the particular ambivalence noted in the *BLAST* diagnosis.

In the photograph, the Fiat is still. Marinetti is wearing a banded wheel cap, like an overgrown Cracker Jack Kid, hands fixed at 10 and 4 on the wheel.

96

New economies of scale and the attendant efficiencies deliver freakish synthetic animals. If new utensils are supplied for gobbling down stuff—cheap silver-plate and plastic cutlery for all—there are also pipe dreams and a host of side effects for reading, thinking, and writing. In one of Wilde's letters of 1900, he breathlessly remembers a ride in a friend's motor car: "The automobile was delightful, but, of course, it broke down: they, like all machines, are more wilful than animals—nervous, irritable, strange things: I am going to write an article on 'nerves in the inorganic world.'"[11] Elephants are very big, motor cars go quickly, modernity revs up thing-play and super-sizes the attendant delights but also accelerates our collective feelings of nervousness, irritability, and agitation. Wilde's craving for speed brings to mind Mr. Toad's wild ride in Kenneth Grahame's *The Wind and the Willows* (1908).[12] As Duffy explains it, Mr. Toad is converted to motorcars just by observing them from curbside. This sort of experience is at the center of a project he describes as "a history of the epistemology of speed in the specific historical period between the beginning of the end of imperialism and the beginning of the era when speed seemed superseded by computer instantaneousness."[13] For Duffy, in other words, this period is coextensive with first modernism. Speed—paradigmatically, driving cars fast—has

two prevailing dimensions. First, it engenders new experiences of affect that are at once "empowering and excruciating." Second, it designates a sociopolitical force field. Here, speed signals a heroic aspect of modernity, mediating experiences of vitality, innervation, intensification, shortened distance, whereas its opposite designates modern hazards such as enervation, backwardness, speed traps, languor, laziness, and boredom.

95

Yielding to the fast, loose, and essentially expressive character of this line of argument, is it a drag for me to point out a key difference between speed and acceleration? Rate multiplied by time is less remarkable than a change in rate multiplied by time. Officer, as the saying goes, I didn't know I was speeding. Or, to point out that slowness itself designates a kind of speed—just as smallness is a type of size? Slowness, like smallness, is scaled by modernity for special consideration. Overwhelming amounts of data necessitate speed reading, skimming, shortcuts and shorthand. The big clock provides an image for administering the modern workday that often designates eternities, as Joyce discerns in his monstrous epic. Einstein discovers that speed is finite—imagining lamps on trains, in fact—a discovery that represents nothing less than a cosmological speed limit. The speeding car, for all its rapidity, presupposes steady hands and nerves for holding still, sitting still, and other kinds of repetitive gestures as well as inevitable blind spots, loss of detail, peripheral vision, and missing frames of reference and other dangers, such as the speed trap and the potential for accidents.

94

"I believe in the horse," said the Kaiser. "The automobile is no more than a fleeting novelty."[14] Inside, other novelties are arrested in their flight from the parking lot to the dumpster. One finds them, for instance, loaded in John Armleder's panel van (Mercedes-Benz 508D, 1994 model year), behind Plexiglas, installed inside the corporate collection at the Mercedes-Benz Museum (*Don't Do It! [Readymades of the 20th Century]*, 1997, 2000). Returning from its second modernist errand to Costco or Carrefour, the van arrives stuffed with florescent-lit bottle racks, urinals, soap powder boxes, sleds, and felt rolls on associational cruise control.[15]

FIGURE 14. *Don't Do It! (Readymades of the 20th Century)*. Furniture sculpture (1997/2000). With permission of the artist, John Armleder. Daimler Art Collection. Photograph by Christof Hierholzer, Karlsruhe.

93

Much of the impetus for taking speeding things seriously owes an intellectual debt to Paul Virilio, but as much pay dirt for thinking about fleeting novelties can be found in Serres's work on Hermes with its many figurations of communication, mediation, translation, and transfer.[16] Following this line, then, speed is a scalar not a vector, because it conveys magnitude not direction. It's hard to tell where anything is going. The very directionlessness of it makes modernity's scalar quality a suggestive way for framing the feeling that modern things are nonprogressive, second modernism, zigzagging and spinning us out of control into a kind of monumental pileup.[17] Where are things going? In second modernity, the pedestrians are the threatened trope, traveling in "the last walking period of man," in Charles Olson's phrase.[18] The literature of Automobilism is consequently reductive, diminished, atrophied by design, with streamlined, road-trip narratives, individual drivers, capsulated and engaging cruise control, and indifferent passengers, with no control over their destinations, as detailed, for example, in Georgine Clarsen's *Eat*

My Dust, which delves into a forgotten archive of minor novels, how-to and advice manuals, and articles and columns in the motoring press and newspapers to explore the invention of the woman driver.[19] Like Duffy's book, it is also essentially a booster's guide to techno-modernity, explaining the political benefits of modern feelings for what's under the hood. Fast cars convert ordinary subjects into "beneficiaries of technological modernity," the joyride becomes a universal solvent of spatial, social, and political limits. The gearhead, as a mechanic-aficionado, finds a heroic aesthetic of modern embodiment, as she is "operating a lathe, using a wrench, driving a car, traveling far from home, changing a tire, having an accident, or burning rubber for fun."[20] Here is a cruise-control version of the familiar cultural studies thesis, namely, consumption redeemed, the perpetual motion machine of thesis statements bottoming out not that too differently from the old advertising saw that *you are what you drive.*

92

In *Objekte im Rückspiegel sind oft näher, als man denkt: Die Auto-Biografie* (Objects in the rearview mirror are often nearer than you think: The Auto-Biography), Matthias Penzel cleverly underscores that the key issue for the automobile isn't who's driving it but whether it's going anywhere:

> Unlike the perpetual motion machine [it masquerades as], a car is not constantly in motion. On the contrary: most of the time it's parked. Even in the automobile graveyard, it defies the ravages of time and decay through its redundant safety components. The automobile is set stubbornly against its presumptive designation and is in no way continuously on the go. And, that is the catalytic converter of irrational and confusing emotions: "Without me, the car is nothing, with me, it's a lot more than me. The superior thing needs me. It is as needy as a child, as domineering as an dictator, and in the middle of it all is me."[21]

Running idle on the driveway, running errands, running around in circles, automobile automatism is overrated. *Das auto ist immobil.*[22] "The car is a vampire that sucks resources," he observes, "it pollutes and destroys the environment, clogs downtown streets, all of which must be wholly

restructured for its needs. It is not simply a conveyance for getting from A to B. . . . It is a mobile dwelling, a fetish object, a polluter, a motor of globalization, a turbocharger for capitalism and assembly line production."[23] Against the fable of automation—lurid fantasies of perpetual motion, conveyer belts and mechanized assembly, automat bakeries,[24] e-books that read themselves "from A to B to Z," Roombas vacuuming the house, when you're away, those oddly personified No. 2 pencils of Leonard E. Read, whose manufacture no one person understands, who nevertheless arrive magically delivering their homilies about free markets—Penzel develops a key lesson for thinking about things in which the critical "journey zigzags, looking at things in the rearview mirror."[25] There is method in things.

9 |

Thinking of zigzagging bodies, then. Observe five chromed pendula, hanging in a small, cradle-like apparatus. Once lifted, the first sphere drops and strikes its neighbor with a satisfying click. The second, third, and fourth spheres remain still, but the fifth pops away and returns, and, with another click, the sequence is reversed. Back and forth it goes, again and again: click, click, click, click, click. Unlike Woody Guthrie's guitar, this "machine" does nothing. I remember coming across one once, when I was small. Sitting inertly on the edge of a grown-up's desk, it was hard to classify: a toy in a puzzling place, amid assorted leather desk accessories and obsolete writing instruments. At the time the thing was billed to me as a perpetual motion machine. It is the first time I recall hearing the word *perpetual*. First built in the mid-seventeenth century, the "machine" was meant as a prop to illustrate several physical laws observed by Isaac Newton and others: the propagation and conservation of momentum, how collisions between elastic bodies transfer kinetic and potential energies.[26] And, if nothing else, the novelty item, still sold under the trade-name Newton's Cradle, makes a ready lesson of the futility of perpetual motion: it's always running itself down, its first collision must always be pre-arranged, the fuse is lit off stage. It's perpetual only when we bracket beginnings and endings from consideration, the effort of a thumb and finger lifting the ball; the force of gravity, drag coefficients, inefficiencies in the apparatus.

90

What's curious is that the prop discloses precisely the wrong lesson. Ironically, the introduction of the phrase *perpetual motion machine*—the association of the prop with the concept it refutes—is what lingers in my memory. The word *perpetual* designating something like a fable of inhuman immortality: the way things go, endlessly at play, irrespective of us. As in *musica universalis*, the music of the spheres, fables of bodies perpetually in motion suggest not only motion as a permanent disposition for things but also that things disclose nonhuman agencies (snowball effects, butterfly effects) that might well be harnessed (exposed, jury-rigged, parasited, feedback looped) to useful, human ends. So seductive is the canard that the U.S. patent office expressly prohibits entreaties staked on claims of perpetual motion to stave off the flood of applicants. So, part of the fascination of Newton's Cradle as it sits on a desk is that, in the guise of a diversion from work, it presents a talisman of perfect work, a totem of perfect efficiency, no winding up or batteries required, a performance of collisions that nonetheless comes to nothing in the end. If the machine, at its simplest expression, is a device that transforms effort in direction or augments its magnitude—working a lever or a pulley, say—this pseudo-machine demonstrates the ways side effects (collisions, domino effects, chain reactions, boomerang effects, Rube Goldberg machines) become contained, dissipate and finally are rendered inert.

89

The title of this *Trauerspielzeug, The Way Things Go*, repurposes the title of a well-known film by the Swiss conceptual artists Peter Fischli and David Weiss, made for documenta 8 in Kassel, Germany, in 1987.[27] Like Newton's Cradle, the thirty-minute DVD became a best-seller of the museum gift shop. Classifying the film generically may be tricky. It shares, with footage of mass manufacturing of crayons, a perennial appeal—above all, for children. Simply put, Fischli and Weiss's *The Way Things Go* shows a carefully arranged sequence of thing-play, things acting upon other things in a kludgey, domino-like fashion: a lit fuse burns away, releasing a tire down a ramp; it rolls over a pair of seesaws and knocks over a ladder before sending a roller skate down a track bearing a lit candle;

more powder flash, spraying sparks onto flammable liquid and lighting another fuse; a bent saw is thereby unleashed, flinging a small flaming missile at a tetherball wound round a pole, which it both ignites and sets loose. Unwinding gradually, the fireball descends and sets alight a pool of fluid, which eventually burns away some of a wooden plank attached to another tire. Enough of this plank consumed, the tire fastened to it begins to roll, heaving the burning member onto a bed of hay, striking yet another fuse, launching a boat rocket, in turn lighting a car rocket . . . and so on for twenty-eight more minutes.

88

Is it a kinetic sculpture? Conceptual art? A performance piece? A narrative film? A posthuman epic? These kinds of questions—classificatory, ontological, administrative—are less informative than the directions *The Way Things Go* points for thinking about things and method. The German title, *Der Lauf der Dinge*, shares a similar idiomatic sense as the translation, human resignation to the inhuman unfolding of events, but the differences in denotation bear some consideration. *The Course of Things*, a more literal rendering of the German, as in a golf course or an obstacle course, gets at the way things often play the part of obstacles, traps, or hazards. Things in the way have a way of becoming things having their way. Dr. Johnson kicks a rock in the road. A way to begin discourse on thingly method: have it your way, thing!

87

Further down, the word *Lauf*—loosely translated as *way, method,* or *course*—derives from the verb *laufen, to run*, an association emphasizing the way things run, the running of things. All those unpeopled discarded shoes and roller skates in *Der Lauf der Dinge* suggest fantasies of automatism, things running by themselves. A similar sense is evoked in English expressions such as *running its course, the run of the house,* or *running amok*. Once machines bear too much human work—running too much for too many too quickly, the way of the assembly line, in so many words—things appear to be running automatically, channeling, like J. G. Ballard's driverless car, the traffic of our desires. We are still, things run past, *as if,* borrowing from Mina Loy, *some patient peasant*

God had rubbed and rubbed the forms and associations of what we want. The human hand in the course of things becomes incidental, absent, or lost. Take the famous "Rosebud," about which Orson Welles says: "It's a gimmick, really, and rather dollar-book Freud."[28] The sled may be the key to the film's narrative, the hushed heart of the newspaper titan's furious empire—*something he couldn't get, something he lost*—but its fate runs its course to no known ends, no better than the cheap novelty item it's linked with, the shattered snow-globe. No one's there when the novelty runs out. When the sled's incinerated, it's a piece of disinterested matter haphazardly pulled from the enormous heap of imperial spoils. Only a camera can bear witness to the inhuman, associational abilities of things.[29]

86

One of the allusions borne prominently by Fischli and Weiss's film is Hans Richter's *Vormittagsspuk* (1928), a film meant to demonstrate, as the title-card reads, "that even objects revolt against regimentation."[30] In a given physical system, this revolt is known as entropy. Richter dramatizes this theme by screwing with time:

> Four bowler hats, some coffeecups and neckties 'have enough' (are fed-up) and revolt from 11:50 to 12 A.M. They then take up their routine again. . . . The chase of the rebellious 'Untertanen' [subjects] (objects are also people) threads the story. It is interrupted by strange interludes of pursuit which exploit the ability of the camera to overcome gravity, to use space and time completely freed from natural laws. The impossible becomes reality and reality, as we know, is only one of the possible forms of the universe.[31]

The technical possibilities of film—with stop motion, variable and reverse speeds, the use of invisible wires and technical effects, the cinematic audience structure, sitting in the dark—enable a trick of animating the inanimate by editing out the human hand. Here, the effects don't so much overwhelm their subject matter as have their way with it. The rebellious *Untertanen*—bowler hats, coffee cups, neckties, a hose, and, not least, the camera—are in charge, moving on their own accord. If

one measures out one's life with coffee spoons, like Prufrock, then perhaps the coffee spoon is right to be fed up. Now, the bowler hat, with or without wires, is in the driver's seat, large and in charge, on associational cruise control. It is, as Peter Wollen argues, simultaneously, a commonplace, a stereotype, a mystery, and a monument.[32] At once ordinary and overdetermined, it's also a joker, in Michel Serres's sense, an associational switching station. It's the hat of the country and the hat of the city; the hat that really won the West; the hat of the gentry and the proletarians; the cabaretists and the modernists. It's the hat on Chaplin, Churchill, Lenin, and Le Corbusier; the trademark of Magritte; the hat one expects on Eliot at work or on Godot if he arrives; the hat shared by detectives, riddlers, and sociopaths.[33]

FIGURE 15. Flying hats—Still from Hans Richter, *Vormittagsspuk* (1928), film

85

What do things do when people are not around? Do they play by themselves, free-associating like words, or, perhaps, do they split off from one another to indeterminate ends? *The impossible becomes reality and reality, as we know, is only one of the possible forms of the universe.* Consider Schrödinger's cat, devised in 1935, as a way to think about a process involving things that may or may not have happened. A contraption is devised:

> A cat is penned up in a steel chamber, along with the following device (which must be secured against direct interference by the cat): in a Geiger counter there is a tiny bit of radioactive substance, so small, that perhaps in the course of the hour one of the atoms decays, but also, with equal probability, perhaps none; if it happens, the counter tube discharges and through a relay releases a hammer which shatters a small flask of hydrocyanic acid. If one has left this entire system to itself for an hour, one would say that the cat still lives if meanwhile no atom has decayed. The psi-function of the entire system would express this by having in it the living and dead cat (pardon the expression) mixed or smeared out in equal parts.

The cat may or may not have been killed, but the point is that, unless someone checks on the cat firsthand, it may well be understood to be both alive and dead at the same time. In the many-worlds interpretation of this paradox, observers are given a dead cat in one universe and a living one in another.[34]

84

We are given the world with the snapshots, the programmed chain of rigged things, we can observe, and remember to communicate about. Something Rube Goldberg knew well:

A) a hook, fastened a complex series of pipes, pulleys, and assorted items, belted to a wool-suited man in a bowler hat, taps B) a boot hanging as signage on a shoe-store, the boot kicks C) a football, over D) a miniature goalpost into E) a net. The weight of the football lifts F) a lever, drawing a sequence of pulleys attached to G) a watering can, spilling water on the woolen coattails of the man. The coattails shrink,

FIGURE 16. Communication Systems—Panel from Rube Goldberg, "Simple Idea to Keep You from Forgetting to Mail Your Wife's Letter," circa 1930. Reprinted in Maynard Frank White, *Rube Goldberg Inventions* (New York: Simon and Schuster, 2000), 159.

pulling a second sequence of I) rigged pulleys, lifting J) the door of a birdcage, releasing K) a bird, who runs down L) a stick, to eat M) a worm, attached with N) a string to O) a retractable screen. This retractable screen contains a message reminding the man to mail the letter in his coat pocket. Goldberg—subterranean sewer engineer by training and honorary Dadaist—is the silent protagonist of this book. His twitter-machines, in which every reaction is diagrammed, algorithmically, are overdesigned sine qua non. They reduce human beings to the muted status of side effects, hapless props belted into the very contraptions designed to facilitate their needs, needs they never knew they had.

83

Like its Goldbergian antecedents, *The Way Things Go* provides pipe dreams about the missing bits of surplus work programmed into things. *Isn't it nice, when things just work* is the tag line for Honda's version of Fischli and Weiss.[35] What's lost, the misplaced human effort, evokes something like melancholy. To stage thing-play, the human element—the coiling of garbage bags, the propping up of tires and sleds, the setting of fuses, the careful balancing of assorted matter—is concealed.

There is no play for things except insofar as they are complicated by sequences of delayed, materialized side effects staged by someone else, somewhere else in advance—would-be collisions, reactions, and falling bodies directed to their cues. Furthermore, inescapable evidence of the expositional necessity of the prop rehearsal is recorded on the warehouse floor. There one finds the implied failures, the missing of marks, the spills, stains, and burn marks. In *The Way Things Go*, in effect, the human is black-boxed inside the machine. The entire operation seemingly captured in one take in real time—cuts and time-lapse disguised in powder flashes, for instance—presenting a mise-en-scène of the human side effect without the human. Indeed, the device is familiar from time-lapse cinematography, the camera left sitting in the farmer's field, capturing the inhuman time scales of seasonal time, climatic change, entropy, and so forth. The ripening and rotting of vegetable love, as Herrick called it. Here, the message is scalar: inhuman potenta is force-fit into the observational framework of human time—more or less, thirty minutes. Entropic deep time dressed up as explosive events; garbage-time remade as novelty time.

82

The Way Things Go puts the improbable illusion of perpetual motion over on its audience. The sleight of hand concealing human beginnings and endings: "Fischli and Weiss remove these things that surround us from their contexts in our daily lives, and then restructure their relationships to one another. The artists aim neither to glorify nor to alienate these common objects, but merely to create new references in which they might be considered," the DVD blurb puts it.[36] Here, the medium matters. The fact that the artists delivered their goods to documenta 8 in Kassel, Germany, on videotape only, and it is now exhibited in continuous loop in galleries blurs the line between infinite and finite feelings, between a video-representation shown over and over and things for which potential energies are unchained but once. The experience of viewing the tape reinforces this association that Fischli and Weiss have somehow fashioned, in the words of one reviewer, "a low-tech perpetual motion machine." "[I] have been watching this forever I can still watch this forever I will be watching this forever," as one commenter remarks on YouTube. Yet, despite this impression, *The Way Things Go* also sits

out of time, all of it happens simultaneously, like an engineer's blue-print, a do-it-yourself kit for the thing-play-machine.

8 |

Thinking about things often seems insufficiently attuned to the particu-larities and peculiarities of their traffic. The literature review of thing theory tends toward anthropomorphism. It's also preoccupied with sto-ries. Things either become ersatz beings or dependencies in ersatz nar-ratives. Determining my desires or circulating my labor, the thing comes to me too well announced. Here it comes as a centripetal force, Freud's thing, driving small-scale relations inward. There it goes as a centrifugal force, Marx's thing, running relations outward into an ever-expanding elsewhere. *The Way Things Go* won't get into such things—not directly, at any rate. Nor still will it explore taxonomies of things—counting, accounting, cataloging, administrating—in short, Foucault's thing, that belongs to the era of "the fabulous development of the book, of print, and the classification of the whole."[37] Things run on mysteries, theo-logical niceties, as Marx says, but they also have their methods, their expositions. It is precisely the sense that, *pace* Dr. Johnson, things are not indestructible—that they fall apart, that their centers do not hold—that interests me; things getting lost, running away with themselves, becoming uncountable and untraceable amid the accumulation. The surprise of the unanticipated thing in the pile provides a critical inter-change at the center of the vortex. Here we may find Serres's joker (the white domino, the blank tile), the concept posed as a thing. As substi-tution, fuzzy association, and pure capacity, it pays forward its "sover-eign logic"; "this is not this; this is something else."[38] Neither subject nor object, it presents an interface that can be anything or anyone. And, tellingly, Serres calls this joker, "an explosive novelty."[39] It alters the pat-tern of play, by altering direction:

> That joker is a logical object that is both indispensable and fascinating. Placed in the middle or at the end of a series, a series that has a law of order, it permits it to bifurcate, to take another appearance, another direc-tion, a new order. The only describable difference between a method and bricolage is the joker. The principle of bricolage is to make something by means of something else, a mast with a matchstick, a chicken wing with

tissue meant for the thigh, and so forth. Just as the most general model of method is game, the good model for what is deceptively called bricolage is the joker.[40]

Or, Flusser's non-thing, the anti-novelty item, as it were, the gadget heralding the dominion of the "vicious cycle" of second culture ("nature to culture to waste"). Non-things "flood our environment from all directions, displacing things," Flusser writes, yielding unscalable mountains of junk: "This throw-away material, all those lighters, razors, pens, plastic bottles, are not true things; one cannot hold on to them. And just as we get better and better at learning how to feed information into machines, all things will be transformed into the same kind of junk, even houses and pictures. All things will lose their value, and all values will be transformed into information."[41] Ephemeral and eternal, the non-thing is "impossible to get hold of," yet it's at the disposal of the information zombies, remote-button pressers, trigger pullers, fuse lighters, and fingertip swipers, those who set in motion preprogrammed chain reactions.[42] Modern things—or better, the jokers and the nonthings—come with conditions. Making sense of them means making sense of these conditions; above all, the appearance of new things, novelties, and the inability to differentiate anything from anything else, waste. Novelty and waste remind us that not even things are things. Nothing beside remains. A Hericlitian point: Even things are not things. What seems firm, solid, inert, is not. Things go away, they get lost. They turn up unexpectedly. Of its own accord, every thing falls apart and tends toward nothingness. This is the way things go eventually. Know this about things: things are moving elsewhere.

Lost and Found

80

Walter Benjamin's Props, *lost and found*. And, then, what of words? Apropos of nothing in particular comes a non sequitur. As it stands, it's also proper to nothing in particular. Nothing at hand at any rate. The non sequitur names that which does not follow. In the informal fallacy by this name, the conclusion does not follow from the premises. It is not proper to them, even though in technical terms it does—syntactically

speaking, that is—follow them. If I am in Kentucky, I am in the United States. I am not in Kentucky—for purposes of this example. Therefore, I am not in United States. Reasonably informed people, who know that the category "Kentucky" and the greater whole "United States" are not identical, know that this does not follow. With other kinds of sentences, more or less than premises, the non sequitur designates a seemingly disconnected or random proposition—propositions that do not follow in narrative as opposed to informal logical: if I am in Kentucky, I am *not* in the United States. In Berlin, perhaps. Seemingly irrelevant to the antecedent but potentially crucial to the consequent. Kentucky as an anomalous state, for example. If I am not in Kentucky, I am not in the United States: Kentucky as a paradigmatic state—in the sense perhaps of Thomas Frank's *What's the Matter with Kansas?* Non sequitur, then, may be best understood as deviation, unexpected redirection of flow. Narrative follows, non sequitur follows otherwise, elsewhere. What I am interested in here in the most general sense is the gesture of turning away, following otherwise, elsewhere—taking breath, to use Benjamin's phrase—as a crucial means of propping the stage for exposition.

79

Expositivity, to coin a phrase, draws discourse away from the prerogatives and metaphorics of narrative toward what Samuel Weber has termed theatricality as medium—or, better: method, and more specifically, toward the role of the prop-er, the one who props.[43] At the Modern Language Association's valediction for one of its grandees, the nearest thing in academia to a celebrity roast, more than once the following zombie concept is ventriloquized from the stage: if you can't state an idea in two or three sentences, it's not yours. A robust, albeit somewhat offhand, assertion of the idea as personal property. And, a hand prop of a definition: it is yours by virtue of property rights theatrically asserted. In other words, an idea comes of its own insofar as it has been acted (on) (somewhere, sometime else) by an owner using words. However cautious we are about the linguistic essentialism found here, or anywhere there's anything proper about the application of words to things, the sense of proper names, referents, or reference, the instrumental placement and performance of the nominal ownership in an object-world plays a crucial if tacit role in our critical languages and professional doxa.

78

For a raw, prop-less thesis of my own—*eidos* on bare stage—I can get no closer than this statement. Yet, the image it conjures—or else the weight it bears—the propriety of absent, archaic (even obscene) acts of naming, also provides a prop, an exaggerated prolepsis of my epistemocritical ends, and, pause for breath-taking "props" to Benjamin, here the point becomes properly his, so to speak. In his account, the appearance of stage props actualizes a break with Classical drama—the birth of the Baroque modernity, the German *Trauerspiel*, the mourning play, marking the death of ancient tragedy—and which corresponds to the arrival of the "profane world of things," the fulsomeness of commodities. Benjamin ties this untimely emergence—and the significance is that the baroque is *not* the romantic—to the origin of the "un-classical." Not romantic apostasy but heretical revision:

> at one stroke the profound vision of allegory transforms things and works into stirring writing. . . . In the field of allegorical intuition the image is a fragment, a rune. Its beauty as a symbol evaporates when the light of divine learning falls upon it. The false appearance of totality is extinguished. For the *eidos* disappears, the simile ceases to exist, and the chronos it contained shrivels up. The dry rebuses which remain contain an insight, which is still available to the confused investigator.[44]

My reading of Benjamin examines his recourse to props: literal props, the way he discusses staged objects in *The Origin of German Tragic Drama*, specially (better translated: *The Origin of the German Mourning Play*); rhetorical props, the stakes of a certain rhetorical placement of the proper status of names as dry rebuses "beneath or against" the proper status of things in Benjamin's thinking; and theoretical props, the dimensions of an expanded concept of props—and the proper, more broadly—for bridging the chasm of two domains of current critical interest: first, keywords, understood as heuristics, zones of theoretical and etymological invention in what Gérard Genette has described as "travels in Cratylusland," and, second, a new, or renewed, theoretical preoccupation with the world of things.[45]

75

The specific application of the term *props* to stage objects comes relatively recently. The OED puts this in the mid-nineteenth century, an abbreviation in theater jargon of the older designator *properties*, significantly citing an appearance in a slang dictionary of the period among its examples. This late terminological arrival presents certain difficulties for early modern scholars, who worry about anachronism. One reason that early modern scholars seem to prefer *stage properties* to *props*, besides anachronism avoidance, is a prevailing interest in the emergence of private property as cultural dominant in connection to the formation of modern subjectivity. Props are *staged property*: in them are disclosed the preconditions of now dominant "patterns of production, consumption, and ownership."[46] Here, we have something akin to the emergence of product placement in James Bond novels, pro-bono work for the subject to the commodity spectacular.

74

And yet, props do more than thematize the discovery of "commodities." They speak to historical changes in the subject/object interface, changes to what Weber has theorized as the medium, that which is at once convention and expression. Props, it seems, the things that above all else present well theatrically, dramatize the world of objects in peculiar ways. Given particular situational contingency, a prop is a thing performing its properties, performing a role sufficiently unto the name, a magic trick of a name that pronounces literally and figurally the same, marking the object itself outside the medium insufficient. A prop must not so much signify in the strict sense as live up to its name as artifice, theater, medium. Are props not essentially a way of treating things not as technics but as media? The prop declaims not so much private property, property taken with you, but property that stays put, property of the house, a vestige of lost communal life and the ruined proprieties of use-value. The status of the term *prop* as a nickname—an improper proper name, redeemed illegitimate speech—conveys something of the legitimacy crisis under which it performs, as it traces the instrumentality and risibility of form half-remembered from beyond/before commodity and exchange value.

73

Furthering this definition suggests a journey into etymology, OED-land, Cratylism. There's a reading of Raymond Williams's masterful *Keywords* in this vein, and its multiform, theatrical gestures, that is, *ah, yes, and here we have yet another of the most complex words in the history of the language at meaning degree zero*—one of my favorite teaching props. Just as inquiry into use-value conceives of an idealized, utopian habitat for things, so too, etymology presents something akin to this for words. As forms of knowledge, both are repeatedly discredited, dead letter offices, deliberately and heretically courting disciplinary exile, but, as digressive methods, modes of thinking, and rhetorics of invention, they call forth tremendous visionary, ethical, and generative chase. They are both, to put it simply, resources of departure not arrival. Part of my impetus comes from Genette's eccentric book *Mimologics*, his "formidable dossier," surveying the persistence and influence of a tradition "which assumes, rightly or wrongly, a relation of reflective analogy (imitation) between 'word' and 'thing' that *motivates*, or justifies, the existence and the choice of the former."[47]

72

Given the topic, it is not surprising that Genette turns to Plato's *Cratylus* to find the original "matrix and program" of this doctrine. In it, one of the more esoteric dialogues, to be sure, Socrates and his foils—Cratylus, the linguistic naturalist, and Hermogenes, the linguistic conventionalist— discuss whether the word's relation to the thing depends on convention and consensus, or whether the relation follows a kind of natural correctness of names. As Genette rightly points out, Socrates himself, whose argument indulges in some amusingly illustrative wordplay about proper names and the names of his associates, in fact rejects both positions, at least in their more absolute forms. Instead, he asserts a radical modification of the latter's position. This so-called secondary Cratylism, or Socratylism, maintains the ideal of a primordial fabrication of proper names, or better, it desires a primordial fabricator, naming the properties of things properly, while also insisting on a rule of subsequent deviation from a thing . . . even to the extent of a deviation degree zero. Genette writes that Socratylism is characterized "by the almost irresistible desire that

its adherents feel to . . . establish or reestablish in the language system through some artifice that [un-restructured naturalists like Cratylus himself] . . . believes to be still or already established there."[48]

71

We could also call the Socratic position linguistic *naturalism lost*. Significantly, and this I take to be one of the position's chief implications, it proposes a legend of method, locating a temporalizing image of the archaic form not at origin but in current usage—a prop in a showplace. As Genette notes, the achievements of the present name-user pausing— searching, taking a breath—to find the proper word—the aptest nickname, the most juice in *le mot juste*—touches, become one piece with, the work of the archaic name-maker, potentially even unto correcting the name-maker's errors. This particular legend of language filiation—the figure Socrates calls the artist of names—I submit, promises and proceeds into something like etymopoiesis. Here I should say Genette and I part company a bit. His notion of *mimologics* attends to the persistent desire for mimesis in correct names, the word "picturing" the thing mimetically or iconically. Following the root *etymon*—the truth in the archaic word—the aspect of the Socratylic method that interests me is its staging of a glimpse or flash of another, more apt word already in the word. To picture this scene means, in effect, finding the truth of the thing in the prop of the archaic word. *Once again, the literal is figurative,* the literal meaning, the proper meaning, is the one that word the (pre)figures, the one that works as a self-referring nickname of the word itself inside the word itself. The literal is figural in yet another way: the word pre*figures* an archaic author-owner.

70

There's also a rationale for this methodological orientation in Benjamin's notoriously esoteric introduction to the *Trauerspiel* book, itself a sharer in Plato's dialogue on naming. In effect, Benjamin proposes the following heretical, preemptory question for both history and philosophy but proper to neither, an analogue to Socrates's breathtaking insight about words: why should thinking about origins be prepossessed by arrival? Here, I trail Beatrice Hanssen in an effort to highlight a reading

of Benjamin's alternative concept of origin as transience, an effort to re-think origin as a critical means of taking leave of the debris-strewn stage rather than a site of laying epistemological and ontological foundation:

> Origin . . . has nothing to do with genesis. The term origin is not intended to describe the process by which the existent came into being, but rather to describe that which emerges from the process of being and disappear-ance. Origin is an eddy in the stream of becoming, and in its current it swallows the material involved in the process of genesis. That which is original is never revealed in the naked and manifest existence of the fac-tual; its rhythm is apparent only to a dual insight. On the one hand it needs to be recognized as a process of restoration and reestablishment, but, on the other hand, and precisely because of this, as something imper-fect and incomplete. . . . Origin is not . . . discovered by the examination of actual finding, but it is related to their history and their subsequent development.[49]

69

Hanssen, with a nod to Emmanuel Lévinas, calls this vector of Benja-min's method "an-*arch*ical," because it turns "origin" away from the tra-ditional Hellenistic *arche* of being toward a Hebraic naming of the "humanism of the other," and, in similar terms, turns Idea from the Hellenistic *edios* to the Hebraic divine "word," the proper name as self-revelatory language.[50] *An-archaic* may be a better coinage yet, because, in addition to the qualities Hanssen describes, it also attends to a consis-tent point of emphasis and interpretive momentum, the *archaic* proper-ties of the cultural materials are the point of departure that count as historical conditions actually formed. The most interpretively relevant commonality of available raw materials at a given time is that their actu-ality always comes saturated with archaic ruin- and rune-like residue. For Benjamin the critic, then, turning away from the archaic is not only a place of constant repetition but also an event of enormous exegetic moment, because the very sense of an object being or existing at the present moment flashes a glimpse of a loss of some prior fragmentary thing. Hence: melancholia. For a specific example only consider the

much discussed auto-authorizing mechanisms of the author's name—the dominion of the Author-god, if you follow Barthes, hagiographic author effects if you follow Foucault, supernatural signatures if you read Derrida. If you read Benjamin, "authors," with their well-known sacralizing implications, provide an im-portant instance of the regulative function of proper names in secularized, "common linguistic usage," era staring eyeball to eyeball with era, exposing a kind of speculative, etymopoetic thinking, heretofore heretical, about history and historiography, and, in this case, exposing the actual insertion of the figure of the author-owners into profane, promotional applications.

68

Recall, then, that *prop* has another definition, unorthodox or tenuous but not irrelevant to this etymopoesis: a prop is a *stick, rod, pole, stake, beam, or other rigid support, used to sustain an incumbent weight; especially when such an appliance is auxiliary, or does not form a structural part of the thing supported.* Also, significantly, a prop can mean a *boundary stake.* It is here that *prop* functions as both a noun and a verb, *to support with or as if a prop, to prop something up*, and acquires something of its technē, the sense of the prop as a tool, instrument, *Werkzeug*: hammers hammer; props prop. Of the archaic words in *props* I'd like to investigate, this is the oldest. The OED puts its beginnings in the mid-fifteenth century, stemming from middle English *prob* and middle low German *proppen*. Although *prop* as theatrical object has a seemingly different filiation—from the Latin *proprius* "one's own, particular to itself"—it has acquired something of the meaning of this other prop as well. In fact, early modern scholars of the *prop* quite self-consciously desire to excise *prop* from *props* so as, in the words of one, to revise "the tendency to regard stage properties as theatrical prostheses, strictly ancillary to and 'beneath or against' the main structure, the play-text."[51]

67

Nevertheless, the sense of *prop* in *props* is stronger stuff than strict etymological reckoning seems to permit. The OED, for example, redirects those who would define *props* to the older *properties*, as in stage *properties: any portable article, paraphernalia, equipment as an article of costume or*

Fig. 5

Fig. 4

Fig. 1

Fig. 6

Fig. 7

Fig. 3

Fig. 2

Henry Mohr; Inventor.
By his Attorney

FIGURE 17. "A kickstand for a thing"—H. Mohr, Auxiliary Cycle Rest, U.S. Patent 1,357,890, filed September 3, 1919, issued November 2, 1920.

furniture, used in acting a play; a stage requisite, or accessory. An obsolete figurative sense applies: props are *mere means.* It's just method. The OED captures this in its example for *props* from 1885: the things in the property room, are called "properties, or, more commonly 'props', so called, I believe, because they help to support the drama."[52] The connotation of ancillary status—that props prop—clings to the word as it moves from the late nineteenth century forward into other institutions mediated by theatrical metaphors: stage-craft proper and improper, circus, music hall, magic and novelty acts, street theater and busking, public speaking, office props, restaurant props, bedroom props, conference props. This resonance is particularly apparent in the French word for *props, accessoires:* accessories, ornaments or decorations, nonessential adornments of the stage—a word Benjamin surely knew. In contrast, the word he employs, the German *Requisiten,* carries the decided implication of necessity: the things carried by a performer during the performance are objects requisitioned by the stage-manager. The word appears throughout the *Trauerspiel* book, though somewhat indifferently translated in the English version, shifting from *staged properties* to *requisites* in a way that makes it easy to lose this thread of Benjamin's thought. And, in a way that the author of "The Task of Translator" could not but appreciate, that the translation of the German *Requisiten* as English *prop* only makes his point even more fully than his mother tongue or, for that matter, the French version. A prop, a requisite, a thing *required* or conventional, for theatrical purpose; a prop, an accessory, an extra thing, appended in an *optional,* or expressive, way: Benjamin's use is both/and not either/or. Here, it's worth pausing again over the prop itself emerging not from performance practice but from stage management, prop-shops, -plots, and -lists; prop-tables, -bins, and -cabinets; prop-hiring and -borrowing, and so forth. With the decay of the commons, common life, community property, *props* become, in effect, staged dependencies, not indifferent or invisible things but lost communal debris. In *One-Way Street,* one of Benjamin's aphorisms compares tourist and theatrical experiences of space, respectively, to visits to the bins at the "Lost-and-Found Office" for property lost and property found.

66

The basic form of *Trauerspiel*, according to Benjamin, cannot be *abstracted* away from the prop bin. It is placed squarely in the profane thing world, and defined from an obligation for a shared stock of props.[53] He employs the parasitical connotation of the word (using the very word parasite, *Parasit*) that makes the thing functionally continuous with other "obligatory ingredients" of the *Trauerspiel*: poisoned rapiers, dreams, ghostly presences, the horrors of an anticipated end, the witching hour, and, above all, the death's head all tumble out of the prop cabinet onto the stage. In props, the historical as unclassical finds its proper site of manifest transience, singularity, and ultimately the intense exteriority of bare, theatrical individuality-in-death.[54] In a related context, Benjamin uses the word for the *artifact, das Zeug*, a word that also means *ordnance* (another of his aphorisms in *One-Way Street* plays up this connection), conveying the explosive, flashbang character of the experience of transience.[55]

65

Benjamin's props argument runs like this: "When, as in the case of the *Trauerspiel*, history becomes part of the setting, it becomes part of the script."[56] The original German makes the point more subtly than does the translation; here's a more literal rendering: with the advent of *Trauerspiel*, history wanders into the scene and becomes part of the prop plot. It both stumbles into the show and becomes an indispensable part of it. In other words, it becomes conventional and expressive—history becomes medium. I suggest what Benjamin has in mind when he writes that this happens in the *Schrift* is that it happens in the transformation of the theatrical script into a property plot, the prop manager's listing of all things needed for theatrical production. Props themselves thus become *conventional and expressive*, to return to the decisive pairing for Benjamin, in that they become vehicles for allegorizing actual bare history on stage, ruins in the showplace for "saturnine beasts" to lie about.

64

The emblem of saturnine melancholy is like a key to the *Trauerspiel* book. It is a crucial preoccupation of Benjamin's, one central to the materials

he considers, explicitly so in his readings of *Hamlet* and Dürer, and more implicitly in his appropriations of *Cratylus*. In *Cratylus*, Saturn, or more properly Chronos, plays a key exegetic role in refiguring origin as the decisive loss of the archaic word. It also prefigures Benjamin's later, extremely influential elaboration of "Left Melancholy," suggesting that melancholy accompanies modern transience through a kind of premature "clowning" of political-historical mourning. In short, as the contents of an overstocked prop cabinet spill out, distracting the house from the possibility of the classical performance of the symbolic and communally coherent death, a kind of unclassical naiveté emerges, a crude theater lost in a fantasy of tumescent objects (*Geilheit* is Benjamin's word) designating on barren terrain:

> Time the decisive category, the great semiotic achievement of romanticism, enables us to fix the relationship between symbol and allegory urgently and methodically. Whereas in the symbol, the sunset's radiance reveals the transfigured visage of nature fleeing into the light of salvation, in the allegory, the consumptive mien of history [facies hippocratica] is laid before the spectator's eyes as a petrified archaic landscape. History from the beginning in everything dilatory, mournful, gone awry is marked on a face—or rather on a death's head. And although this thing lacks all "symbolic" freedom of expression, all classical proportion, all [common] humanity—it offers up meaningful pronouncements to the riddles not only about bare human existence in nature but also about the biographical historicity of the individual figure most debased by nature. This is the core of allegorical spectatorship in baroque modernity, profane historical exposition as the passion-play of the world; its meaning resides solely in the stages of the decay. The greater the meaning, the greater the deterioration unto death, because death digs most deeply along the jagged boundary between body and meaning.[57]

In this stage as overfull wasteland, freighted with lethargic beasts and other morbid junk, sits Benjamin's other angel, winged melancholy. Now, what was it he's forgetting to announce? A delayed arrival? A premature appearance? And, who was coming? The allegory reader as critic? The

FIGURE 18. "Benjamin's other angel"—Albrecht Dürer, *Melencolia I*, 1514

legislator of the actual? Or, was it the name maker, the first glimpse of the artist as producer?[58]

63

Pace Benjamin, there is a locus classicus germane to the emergence of props from otherwise prop-less antiquity: Plato's cave, or, following the

Benjaminian temporal scheme, from a reading of it as an allegory of enlightenment-restraining prejudice initiated on the cusp of modernity. Here, think of Bacon's four idols, the tribe, the market, the theater, and, of course, the cave. Plato's legendary "home theater," as Weber calls it, positions subjects in "theatrical singularity."[59] Captive audience members are restrained as so many saturnine beasts unable to recognize the stakes of their own theatricality in the shadow play that properly possesses them. Above all, this means they do not grasp their own fantasies, their *Denkbilder*, as props, instrumentalized by mysterious prop managers, the real, albeit always archaic, stakeholders in things.

<div style="text-align:center">

62

</div>

Weber poses a number of questions about these seeming bit players: Who are they? What do they want? What is their ontological status? What is their political motive? "How do they relate to that enthralled, spellbound audience of spectators-prisoners?" "How do they relate to the organization and significance of the 'spectacle' itself?"[60] A glimpse here of the curtained prop closet, stage left, the being told not to look at the great and powerful Oz. Before speculating about the prop managers, though, I'd like to think through Benjamin about the status of the props themselves. What do they want from us? Variously described as implements and as puppets of animals and of men, these are not unmotivated things but rather props as *mere method*. Is mere method artifacts or ordnance? Are the implements of shadow-play instruments of work or play? Work for some; play for others? Is it the theatricality of actual critical production, of which Plato's allegory is a key precedent, modeled as it is as theater and commentary, that which is allegorized?

<div style="text-align:center">

That Swell New Thing

61

</div>

That Swell New Thing. The things spilling from modernity's prop locker may be best understood with reference to the sudden appearance of seemingly inconsequential novelty items—itching powder, exploding cigar, fake dog shit, joy buzzers. Chris Ware's *Acme Novelty Library* provides an instigation:

FIGURE 19. "Here's the Swell New Thing!"—Chris Ware, *Entertainment Weekly* (March 22, 1996): 3.

Fellas & Gals! Here's the swell new thing!
Your very own Osc'r souvenir statuette:
Wow! It's the top shelf trophy of our nations imperial culture.[61]

It's hard to tell if these faux advertisements really mobilize a subjective
message about "ironies of commodification," as David Ball asserts, or if
they constitute a kind of homage to the explosive potential of modern
novelties to disclose both horrors and charms.[62] These are things that,
as Sartre puts it, "abruptly unveil themselves . . . as hateful, sympathetic,
horrible, lovable."[63] Your very own scary, life-size monster: "Obeys your
commands!" Your very own exploding army grenade: "Really scatters the
gang when you throw this baby in their midst." Oscar statuettes, life-
size monsters, fake grenades: All these items, occupying the imaginary
interface between stuff and waste, return us to paleofuturist history and
the critical project Bill Brown has termed *thing theory*.[64] There is a strange
bounty of unkindness, crammed in the uncanny inventories detailed
in the back matter of comic books and *Popular Science* and *Popular
Mechanics* magazines as well as the catalogs of such twentieth-century
manufacturing concerns as S. S. Adams Novelty, DeMoulin Bros. & Co,
and Richard Appel Co. Modernity gives things a certain inherent theat-
ricality dimension—props, pranks—that registers a profound ambiva-
lence about the "object[s] materialized by human attention," to borrow
a phrase from Brown.[65] The comic cruelty of the novelty gag provides
us an occasion to think about a powerful shift in the relations between
goods and hazards with respect to the meaning of the cultural turn and
the burden of the new in second modernity.[66]

60

I remember a novelty item one of my classmates smuggled into my
second-grade class. A fake "spill" made from a solid, resin material so
there is absolutely no mess to clean up! as the ad copy still reads from
the Johnson Smith catalogue. Imagine the fun you can have fooling
your friends, family, and coworkers. Embedded in the fake spill, there's
a real twelve-ounce can, the empty lying on its side, haloed in a lake of
fake soda: a waste product manufactured to appear as if vomiting more
waste. But, the novelty of it is the doubled surprise, the fakeness of spill;

the thing that marks the difference, the prop that organizes the theater, unmasks bad fortune as merely mock abuse. I don't remember seeing the fake spill itself until it was already in place, carefully staged for maximum effect upon the desk of our teacher after she'd been called away somewhere. With my fellow second graders, I paraded by, studying it. The effect was catastrophic: the sprawl of important papers—were they lesson plans? our schoolwork? her grade book?—destroyed by the dark liquid drooling obscenely from the aluminum can. It took dominion everywhere, like Wallace Stevens's jar in Tennessee. We just managed to retake our seats before she returned, finding it hard to suppress giggles. I don't recall her outburst precisely; only its severity, that it was shocking at the time: *You fucking kids*—something on that order. There may not have been profanity. I think it was our laughter that must have been so offensive, a conspiracy of juvenile unreason felt by authority. Someone— not the perpetrator—even spoke up: *But, Mrs. H., it's not real. It's only a joke. Still,* she said. *That doesn't change it,* as if the one subject to the exploding cigar, the buzzed handshake, the emptied fart bladder gained nothing by playing along. Imagine the fun you can have, yet whatever the outcome, as every kid knows, the fake and the real are different theaters of cruelty.

FIGURE 20. Spilled Soda Can—Photograph by author. Copyright Aaron Jaffe.

59

In "The Discovery and the Use of the Fake Ink Blot," originally pub-
lished in *Playboy* in 1966, Woody Allen facetiously chronicles the devel-
opment of a cognate novelty item, the fake ink spill, with bottle. The
story begins with following sentence: "There is no evidence of a fake ink
blot appearing anywhere in the West before the year 1921, although
Napoleon was known to have had great fun with the joy buzzer, a device
concealed in the palm of the hand causing an electric-like vibration
upon contact."[67] According to Will Self, Allen's tale is "a mock serious
commentary on the very unfunny nature of the pratfall."[68] In fact, oddly
enough, Allen's premise is more subtle: he twins the rise of the "cunning
little gimmick," the disposable item of juvenile sadomasochism, to the
rise of the cunning of history, the self-positing world-historical actor. In
effect, Allen points to the etymology of catastrophe—overturning—by
connecting unexpected reversals at wildly different scales. Not only did
Napoleon deploy joy buzzers on "unsuspecting" dignitaries, but Anto-
nio López de Santa Anna, the Napoleon of the West, devised spring-
loaded chewing gum booby traps for cheering up the holdouts at the
Alamo. Catastrophe, minor and major. Robert E. Lee goes in for squirt-
ing flowers; J. P. Morgan, sneezing powder; Rockefeller, snakes-in-a-can.
Something of this dynamic, the incongruous idea that figures astride
world history occupy themselves with novelty items, can be seen in the
ubiquitous lore of exploding cigars as staples of global intrigue—supplied
by Hemingway or U. S. Grant to various grandees, or by the FBI to
Castro. Does the prank item promise a thing for striking through visible
objects as so many pasteboard masks, like Ahab putting an explosive
stogie over the whale?

58

When it comes to fake ink blots, Allen writes, they were first crude and
uselessly large, "eleven feet in diameter, and fooled nobody," until 1921,
when a certain Swiss physicist discovered "that an object of a particular
size could be reduced in size simply by 'making it smaller,' [and then]
the fake ink blot came into its own."[69] The fame of this fake ink blot—
the novelty of the item—doesn't come until 1934, when FDR figures out

how to use it to settle a strike, bringing labor and management together in mutual culpability as suspects before someone's spoiled sofa. First, it's made small, then it's put in service of big business. In each of these cases, taking a page from E. E. Cummings, the victim "safely plays with *the bigness of littleness: / electrons deify one razorblade / into a mountainrange*."[70] The novelty is a real abstraction, an inert stopgap between theoretical possibility and functional application. The blot came into its own and remained in its own, as Allen's odd assertion has it, until it was removed from its own and placed in someone else's.

57

Allen's chronicle makes a hash of the historical record of the advent of manufactured novelty items. Certainly there were precursors—improvised jokes of various types—but the manufacturing boom yielded sneezing powder, itching powder, exploding gimmicks of all sorts from cigars to pencils to golf balls, fake vomit and dog shit, joy buzzers, whoopee cushions, bugs encased in fake ice cubes, all goods that make their historical appearance in the first decades of the twentieth century. The joy buzzer may have been the flagship item, but the large-scale manufacture of novelty items was borne in a nimbus of sneezing powder. In effect, this paradigmatic novelty item closely follows the cultural style of second modernity, in particular mimicking the genius of new forms of applied knowledge—namely, chemical engineering—for extracting value from by-products, side effects, and waste. Adams wasn't a chemical engineer himself, but in 1904 he was working as a salesman for a concern that manufactured chemical dyes. These dyes were derived from coal tar, itself a leftover from refining coal into coke, discovered to yield fantastic new chemicals in the late nineteenth century. Adams's firm obtained coal tar from Germany and was in turn left with various waste products of no known use, including most notably a certain fine brown powder that caused sneezing fits. Adams saw potential in bottling and selling this irritant as a social prop, dubbing it "Cachoo." By 1906 he had quit his job, secured a supply from his former employer, and set up shop. The following year Adams applied for a patent for a miniature bellows for delivering his brand name product surreptitiously in social settings.[71] "Make the whole family and all your friends 'just sneeze their heads off,'

without knowing why, with CACHOO, the long distance harmless snuff," read the ads.

56

Long distance irritation was exactly the order of the day: the fad for Cachoo took the country and the world by storm, and eventually the stuff was banned by bewildered customs agents in such far-off places as Australia. More to the point, some fifteen years after Cachoo's introduction into the marketplace, it was chemically identified in a scientific paper, and, somewhat later, this mucous irritant was discovered to be a hazardous material, dimethoxybenzidine, shown to cause tumors in rats.[72]

FIGURE 21. Sneezing Powder—Diagram by Stephen B. Jaffe. Copyright Aaron Jaffe.

For our purposes, the story isn't a moral fable about the inescapable dangers of science but rather a culture message about the ways the novelty item vernacularizes regressive uncertainties of the inevitable side effects of modernity. A concern takes a former non-thing, a waste product, and processes it into a good: blue dye. What's left over in turn— more waste, in effect—is known to produce a side effect—sneezing— for which a market is adduced, a destiny in the world of goods. Even though the appeal is always framed in terms of a decisive harmlessness, it's never a secret that the desired end entails the unleashing of side effects, that the form of mischief promises an unknown portion of mayhem, and that this good is at best morally ambivalent. In this way, the thing

at hand, to adapt Brown's formula, is "an object materialized by human attention" to unknown consequences.[73]

55

S. S. Adams's storied meeting with an admiring Henry Ford suggests that heroic fables of mass-produced goods run side by side with the fables of mass-produced hazards.[74] Woody Allen's expressive link between the catastrophic arrival of the Romantic hero and the shock of the vernacular modernist object has its appeal. To think things such as these as goods is itself strange—the secret life of novelty items puts pressure on the received idea that goods are good. It's useful to consider that novelty items were produced and sold by the same concerns that shifted magic tricks. If things want something from us, an affective accommodation to their agencies, the novelty item suggests that things want to trick us in some fundamental way. Or, phrased differently, the novelty item discloses a decisive unwillingness about our perfunctory accommodation to the alleged unconscious lives of things.

FIGURE 22. Child with Hobby Horse— Source, M. L. Kirk, *Favorite Rhymes of Mother Goose* (New York: Cupples and Leon Company, 1910).

54

The novelty remains the apt designation for this stuff—better than the trick, trinket, widget, prank, or gag—because it means both a thing and a property about a thing. Something new, not previously experienced, unusual, or unfamiliar; a novel thing. Importantly, it carries a pejorative undertone. Thus, in 1868, per the OED: "They're the novelty quite, but chancy things to sell." An often useless or trivial but decorative or amusing object, especially one relying for its appeal on the newness of its design. Specifically, a small inexpensive toy or trinket; of an unusual, innovative, and often decorative or frivolous, design or type. The OED puts it this way: *novelty item, noun, a new item; something which has never been encountered before* [with the implication that it will quickly disappear]; *specifically a frivolous thing, which has a certain amusement value, but usually little else to recommend it.* Ironically, considering the wasteland of defunct manufacturing concerns in the United States, these products, which are still made by many of the factories that originated them decades ago, are remarkably healthy today in the postindustrial present. The unmentionable item produced by the family firm of Chad Newsome in *The Ambassadors* may well be a fart bladder or one of these—

FIGURE 23. Marcel Duchamp's *Bicycle Wheel*—Drawing by Patrick Odom, www.patrick-odom.com. Copyright Aaron Jaffe.

instead of the speculated pencils, coat hangers, or toilet seats. Whatever else these are, they are unquestionably good goods. The novelty comes specially marked with its own special form of value. Not value in use or exchange: Novelty value has its own appeal. Novelty value is about all it's useful for—is the OED's example. Make it new may not mean make it small, frivolous, and out of control; but configuring a thing, a property, and a theory of value under the sign of novelty is modernist formula par excellence: make a thing shot through with risk, know that stuff might be waste, that the hand before you stretched to greet you, might conceal an unpleasant jolt.

FIGURE 24.
Dribble glass—
Source, Kirk
Demarias, *Life of
the Party: A Visual
History of the S. S.
Adams Company*
(Neptune, N.J.:
S. S. Adams,
2006), 97.

53

In "The Painter of Modern Life" (1863), Baudelaire writes that "the child sees every thing as a novelty; the child is always 'drunk'. Nothing is more like what we call inspiration than the joy the child feels in drinking in shape and color."[75] For this side of novelty, think of the fate of the glass merchant of Baudelaire's fable, where, in effect, amusement and intoxication enter modernity astride a dribble glass.[76]

The splenetic narrator throws the door-to-door salesman out the door and to the curb for not stocking "pink, red, blue glass, magical windows, windows of paradise": "How impudent you are!" he tells him. "You dare to parade about the poor quarters, and you don't even have window-panes that would make the world look beautiful!" As the merchant retreats, the narrator bombards him with a flower pot—he calls it an engine of war—and at last achieves a desired effect, an "explosive noise of a crystal palace shattered by thunder" and more importantly a profane view through x-ray specs onto paradise: "Drunk with my madness, I shouted down at him furiously: Make life beautiful! Make life beautiful!" Napoleonic joy buzzers aside, this scene is certainly ground zero for the modernist novelty item, in which what's for sale can't live up to the desires it mobilizes. About two points Baudelaire is quite clear: first, it's a prank, and second, the prank's function is to mobilize risk: *innervating novelties come with perils and costs*, runs the penultimate non-moral: *But what's the risk of an eternity of notoriety compared with the gain of an instant of infinite enjoyment?*[77]

52

Nineteenth-century Paris was designated as the nexus of this experience, modernity as an encounter with the now as a childlike show-and-tell with novelty, where new sensations about goods, feelings of exultation, and ambivalence about commodities whirl about in a vortex. "Modernity's child is sated by surface alone," Brown writes.[78] Where all the stuff and waste originates is another story—in the East perhaps, with the eleven-foot diameter ink blots—but here in Paris, the cosmopolitan site where everything is displayed under glass, it's all put in dialectical relation. Of course, this is Benjamin's position, but one sees the persistence of a similar fable one hundred years after Baudelaire in the *Lavender*

Hill Mob (1951; dir. Charles Crichton), the Ealing Studios caper film about smuggling commodity gold out of London to Paris in the form of dummy Eiffel Tower mementos, fated to be sold to English tourists.

FIGURE 25. Man Ray's *Gift*—
Drawing by Patrick Odom,
www.patrick-odom.com.
Copyright Aaron Jaffe.

Return to the scene of the modern and you find the novelty item. In "Kora in Hell" (1920), William Carlos Williams writes: "If a thing have novelty it stands intrinsically beside every other work of artistic excellence. If it have not that, no loveliness or heroic proportion or grand manner will save it."[79] In novelty alone, an item, in effect, holds its ground with other more properly aesthetic—if un-modern—virtues: loveliness, heroic proportion, grand manner. Man Ray's *Gift* comes to mind. Exhibited in Paris in 1921, alongside works he brought in a steamer trunk from the United States, this novelty was fashioned the very afternoon the show opened: "He glued a row of fourteen tacks to the bottom of a [painted flat] iron. With its menacing blend of domesticity and sadomasochism, the object apparently attracted unusual attention—by the end of the day, *Gift* had vanished."[80]

FIGURE 26. *Papier-mâché Flat Iron*—Source: Kirk Demarias, *Life of the Party: A Visual History of the S. S. Adams Company* (Neptune, N.J.: S. S. Adams, 2006), 36.

50

Two years earlier, T. S. Eliot had mentioned novelty three times in "Tradition and the Individual Talent": first, to say, with Williams, that "novelty is better than repetition," however lovely, heroically proportioned, or grand. Second, more famously, that "the existing order is complete before the new work arrives; for order to persist after the supervention of novelty, the whole existing order must be, if ever so slightly, altered; and so the relations, proportions, values of each work of art toward the whole are readjusted; and this is conformity between the old and the new."[81] The appearance of the extraneous thing takes on an aesthetic dimension but one wholly dependent on its careful placement among more traditional furniture. Third, discussing eccentricity in poetry, Eliot warns that to "search for novelty in the wrong place" is fraught with hazards, which

he describes as the discovery of the perverse.[82] Yet, an encounter with perversity of novel sensation is also somehow the source of the charm of things. "Is there something perverse, if not archly insistent," asks Brown, "about complicating things with theory?"[83] And, one might also ask similar perversity of complicating things with novelty? The pervert's guide to things—taking a page from Žižek—is a suitable name for a novelty item catalogue. Jean Sheppard calls novelty item catalogues "an exotic mixture of moralistic piety and violent primitive humor."[84] The role of catalogues not merely as practical tools for measuring relative exchange values but also for reckoning exchange value with novelty value: Johnson Smith & Co side-by-side with Sears Roebuck.

49

Flotsam and jetsam, ply-on-ply. In 1912 Hart Crane's father invented Life Savers. The reason they look like small life preservers owes something to the then recent Titanic disaster and the sudden novelty of a particular thing in popular culture, the life preserver. One prevalent idea is that Life Savers have their form—clean white tori—because their inventor's daughter choked and died on an unsafe, unimproved mint. As urban legend, the story rehearses a familiar form of semiotic literalism, detecting a causal relation between signifiers and signifieds. Mint-formed use-value: the mint holed to express a message, a warning of sorts, mint surrounding the void to signify the risk a small thing might get lodged in a small place. Tellingly, the actual, daughterless confectioner is not interested in things but words—the proper name, the trade name Life Savers, sold to buyers the following year. It was not sold as a patented process or a safety advance—enough information alone to refute the literalists—even if the novel shape does imply the application of patent pill-making know-how to confectionary, a story from cough drops to gum drops familiar enough from the druggist trade. The reason the Life Savers patent is superfluous is that "Life Savers" effectively designate the alpha and omega of form itself: "for that stormy breath," of briny seamen, who ought to reach for one, prominently featured on the illustration of Crane's packaging.[85] Like his father, Hart Crane is a confectioner of metaphoricity. "At Melville's Tomb" explains a wager concerning the submerged currents and communications in things:

Often beneath the wave, wide from this ledge
The dice of drowned men's bones he saw bequeath
An embassy. Their numbers as he watched,
Beat on the dusty shore and were obscured.
And wrecks passed without sound of bells,
The calyx of death's bounty giving back
A scattered chapter, livid hieroglyph,
The portent wound in corridors of shells.
Then in the circuit calm of one vast coil,
Its lashings charmed and malice reconciled,
Frosted eyes there were that lifted altars;
And silent answers crept across the stars.
Compass, quadrant and sextant contrive
No farther tides . . . High in the azure steeps
Monody shall not wake the mariner.
This fabulous shadow only the sea keeps.[86]

As Crane explains to Harriet Monroe: "Dice bequeath an embassy, in the first place, by being ground . . . in little cubes from the bones of drowned men by the action of the sea, and are finally thrown up on the sand, having 'numbers' but no identification. These being the bones of dead men who never completed their voyage, it seems legitimate to refer to them as the only surviving evidence of certain messages undelivered, mute evidence of certain things, experiences that the dead mariners might have had to deliver. Dice as a symbol of chance and circumstance is also implied."[87] That mute, undelivered things have messages is no certainty. Consider Eliot's Phlebas—Crane's secret sharer—and his rejected life saver:

Phlebas the Phoenician, a fortnight dead,
Forgot the cry of gulls, and the deep sea swell
And the profit and loss.
A current under sea
Picked his bones in whispers.[88]

What Crane tells Monroe is merely a dicey, communicational wager about entering this whirlpool: amid all the anonymous plastic micro-pellets

in the great oceanic trash vortex, a handful of novelties, a few auto-associational buoyancies, are bound to pop up from the deep.

48

In *Graphs, Maps, and Trees,* Franco Moretti notes the "extreme visibility" of certain things when they first appear in village chronicles of the late eighteenth century, the Age of Wonders, he calls it. Not yet manufactured goods but goods of long-distance trade, goods of Empire, these novelties—sugar, coffee, salt, a parrot, a coconut—designate things from the outside world, another world: "They shine for a moment on the horizon of the everyday," he writes, "leaving behind a sense of incommensurability: on one side birth, labour, marriage, and death; on the other, coconut." In the world of novelties, "wonders appear, are admired, and then vanish."[89] They vanish not because they physically disappear but because they become ubiquitous. We get from Moretti's coconut to Baudelaire's orange when we consider the ways manufactured things try to squeeze the same affective currents stolen from novelty items, more juice forced out from old, borrowed fruit.

Returning to Brown's formula: a thing is "an object materialized by human attention."[90] The recent interest in thing theory is really little more than a thing preoccupation: a thing thing. The thing for things is prepossessed by a distinction Heidegger draws between objects and things whereby things are objects re-formed.[91] An object becomes thing when it stands out, when it holds itself up to a higher standard. Reformed in things, raw materials extracted from the object-world, are made self-supporting and ready to use. Heidegger's key examples—a jug, an axe, and a shoe—get at this in-forming and elicit his primordial nostalgia about putting handcrafted stuff in reach by dispelling distance. The earthenware jug nearby—arresting a void, promising libation—provides an occasion to expound a "cosmological poetics," in Brown's phrase, the so-called fourfold of earth, sky, divinities, and mortals.[92] Reaching for the thing discloses a kind of secret about spending time with companionable smalls. As opposed to the inert object-world, where nothing stands at the ready, smalls release agencies, personalities, private lives, desires, interiors, lies, and irresponsibilities.

FIGURE 27. Marcel Duchamp was here—graffito. From "Street Art at Its Best: Duchamp Was Here," Wooster Collective. Photographer unknown.

47

What happens to a thing in a market, then? When stuff is counted as goods, it's sent out, elsewhere to distant places. Strange things ensue, as Marx observes:

> At first sight [a table] appears an extremely obvious, trivial thing. . . . The form of wood, for instance, is altered if a table is made out of it. Nevertheless, the table continues to be wood, an ordinary, sensuous thing. But as soon as it emerges as a commodity, it changes into a thing which transcends sensuousness. It not only stands with its feet on the ground, but, in relation to all other commodities, it stands on its head, and evolves out of its wooden brain grotesque ideas, far more wonderful than if it were to begin dancing of its own free will.[93]

Is there such thing as a circulating thing, or does circulation mean the end of thingness as they are leveled, stripped of sensuous distinctions,

set in motion, and sent away? The Heidegger–Marx dispute seems to recapitulate an unsettled fallout about use and exchange, recapitulating two seemingly incommensurate modes of value: one felt in the solidity things at hand and the other felt in their slipping through one's fingers. In both cases, one is left with an uncanny aftertaste of agency.

<h1 style="text-align:center">46</h1>

Novelty items go a long way toward demonstrating that this quarrel between use and exchange is not particularly helpful when understanding these agencies, the respective niceties and perversities of modern things, tipped-over jugs encased in faked spills, shoes that occasion the hot foot, axes with the rubber handles. Robert Chodat observes there's "widespread uncertainty about what kinds of things should be treated as sentient and sapient, as doers and thinkers."[94] It makes sense to think of novelty items as the material expression of this uncertainty. Side effects, waste products—quasi-things, following Michel Serres, unstable nonthings, following Vilém Flusser—however auto-theorizing, take no side in the controversy of precedence concerning subjects, objects, or even things.[95] Recall once more Benjamin's notion is that newly "tumescent" items spill onto the stage of modernity as if from a prop cabinet. In so many words, he reminds us that they come saturated with explosive theatricality. The noun *Zeug*, familiar from compounds like *Spielzeug* and *Werkzeug*, Benjamin notes, on its own does double duty as the word for prop and for ordnance. Indeed, it's a word that also means trinket—in essence, a novelty item.

45

The cue that New York Dada claimed Rube Goldberg.

FIGURE 28. Dada Goldberg—*New York Dada* (April 1921), 3; see also, Robert Motherwell, *The Dada Painters and Poets: An Anthology* (Cambridge, Mass.: Harvard University Press, 1979), 217.

One way to consider the on-board theatricality of things is in terms of a widespread uncertainty that inheres in them and the moral ambivalence of our inescapable accommodations with them. Take the truism, attributed to Oliver Wendell Holmes in 1919, about goods that "the ultimate good desired is better reached by free trade in ideas . . . that the best test [of this good is] to get itself accepted in the competition of the market."[96] It's a faulty analogy—among other things—because all goods are not good, or because goods are not always good. The good that seems like a fetching hand reaching out to meet and greet you may well conceal an unpleasant jolt with a joy buzzer.

FIGURE 29. "Joke buzzer"—S. S. Adams, Joke Buzzer, U.S. Patent 1,845,735, filed November 12, 1931, issued February 16, 1932.

In fact, as we've seen, marketplaces take special note of such things, the novelties, the things that stand out. The analogy that figures ideas as goods forgets that, like quasi-ideas, goods come steeped in risks and side effects, and non-things are encountered in foretastes and aftertastes of waste.

44

Brancusi's Golden Bird

The toy
become the aesthetic archetype
As if
some patient peasant God
had rubbed and rubbed
the Alpha and Omega
of Form
into a lump of metal
A naked orientation
unwinged unplumed
the ultimate rhythm
has lopped the extremities
of crest and claw
from
the nucleus of flight
The absolute act
of art
conformed
to continent sculpture
—bare as the brow of Osiris—
this breast of revelation
an incandescent curve
licked by chromatic flames
in labyrinths of reflections
This gong
of polished hyperaesthesia
shrills with brass as the aggressive light

strikes
its significance
The immaculate
conception
of the inaudible bird
occurs
in gorgeous reticence[97]

 Mina Loy

Loy's poem—published in the celebrated November 1922 issue of *The Dial* that also launched *The Waste Land*—glosses the main points of my essay. An instructional manual for accessing novelty, it provides, in effect, counsel about the mode of sensible being proper to modernist

FIGURE 30.
Brancusi, *Golden Bird—The Little Review* 8, no. 1 ("Brancusi Number," Autumn 1921): 99.

artistic products, an anticipatory amicus brief—recommending a second look at things that first appear more akin to manufactured objects than anything else. Indeed, it anticipates the very terms of the legal case brought only a few years later to contest import taxes levied against one of Brancusi's space-age birds that seemed to resemble either some kind of kitchen utensil (a potato masher, supposedly) or a surgical instrument of mysterious utility (an x-ray tube, perhaps).[98] Instead of the familiar *ut pictura poesis* analogy—poem mimicking painting, as it were[99]—the poem poses a critical legend. The modernist aesthetic event re-mediates the situation of humans and things being caught up in the all-too-modern fate of novelty and waste. Sequence is screwy here: toys precede archetypes; raw materials get second-handed in their otherworldly resting places; exteriors get tethered to interiors with explosive consequences long before their conception. The hard past tense of Loy's first line ("become") suggests that the staging of form happens outside any creaturely workshop. Inside the archaic junkshop, then, the *patient peasant God*, streamlining ex nihilo, is *not* a proxy for the direct carver—*not* a mythic artificer of wooden or stone prototypes suited for sub-creation through metallurgy. Instead, this figure is a long-suffering collector of novelties browsing amid all the inhuman yields of entropy.

43

The famous incident that inspired the readymade is relevant here. Arthur Danto calls it "the defining anecdote of modernist art."[100] Eyeing a propeller at an aviation exhibition, Duchamp tells Brancusi: "Painting's washed up. Who'll do anything better than that propeller? Tell me, can you do that?" Amazingly, Brancusi's own reception arrives via an interzone Duchamp foresaw where novelty gets redeemed from waste; *Bird in Space* resembles, according to one bemused journalist, for instance, nothing else besides "half of an airplane propeller."[101] In effect, a ruined instrument (of human flight) cracks the mirror to nature. Unlike the urinal, the bottle rack, or the bicycle wheel fastened to the stool—manufactured items liberated from their applications, as it were—Brancusi's animal-machines become crucibles for transforming associative interruptions into hard gemlike flames. Extraneous animal spirits get vaporized ("extremities/ of crest and claw"), and all that's left over is a protean bolus. The remainder

qua remainder crucial to this critical alchemy is a luminescent tube as Loy describes it, an "incandescent curve/licked by chromatic flames." These "labyrinths of reflections"—repositioning subjects and objects—announce peculiar second modernist outcomes that, in Ezra Pound's words, "revolt against . . . solidity."[102]

42

Insofar as Loy's poem "tries to fuse artist, object, and viewer response into one synesthetic experience," it's worth noticing that her brief on Brancusi—like Pound's essay on the same front—depends on an already mediated experience.[103] One way this happens is by redirecting traffic over highly polished surfaces at an item reflecting photographic flash—flash that originates not incidentally in Brancusi's own efforts to promote his work. The striking images of the *polished hyperaesthesia* in the Brummer Gallery exhibition catalogue, which accompanied the publication of Loy's poem and Pound's essay, are all taken by the artist himself. As Margherita Andreotti notes, they advance an aesthetic of

> mirrorlike surface [that] brings light, space, and the immediate environment into the work while reducing the sense of weight and mass traditionally associated with sculpture. When struck by a source of light, the reflective surface can give the illusion that the sculpture actually radiates light, an effect captured dramatically in Brancusi's photograph. As Man Ray, the artist who is generally credited with introducing Brancusi to photography, recalled upon seeing the sculptor's early photographic prints, "One of his golden birds had been caught with the sun's rays striking it so that a sort of aura radiated from it, giving the work an explosive character."[104]

In effect, what *shrills with brass as the aggressive light strikes its significance* is the inevitability of technical mediation—in this case, an encounter with flash. It's this interruption, above all, that overburdens Brancusi's bird-associations—the ones that call to mind Pound's comments about his "research for the aerial" releasing us from the inevitable grounding owed the Earth: now propeller, now antenna, now flame.[105] Whether cylinder or container, concave or convex, the void contained inside is

exposed as if flashed from inside blown glass. *Starts like a contest. Ends up with the biggest laugh you've ever had.*

FIGURE 31. Squirting swan pipe—Kirk Demarias, *Life of the Party: A Visual History of the S. S. Adams Company* (Neptune, N.J.: S..S. Adams, 2006), 36.

41

FIGURE 32. "Ceci n'est pas une pipe"—René Magritte, *La trahison des images*, 1928–29. Magritte: Copyright 2013 C. Herscovici, London / Artists Rights Society (ARS), New York.

As Foucault describes it:

> The first version, that of 1926 I believe: a carefully drawn pipe, and exposition underneath it (handwritten in a steady, painstaking, artificial script, a script . . . like that found heading the notebooks of schoolboys, or on a blackboard after an object lesson): "This is not a pipe."[106]

The most familiar reading of this image is as a structuralist gloss on representation: a drawing representing a pipe is not the pipe itself. This is the standard gloss, one promoted by Magritte himself: "Could you stuff my pipe? No, it's just a representation, is it not? So if I had written on my picture 'This is a pipe,' I'd have been lying!"[107] What ever else this is, reads the legend, this is not a pipe. Magritte saw it as an emblem of the ascendancy of poetry over painting. As Foucault writes in his book: "A drawing representing not a pipe at all but another drawing itself representing a pipe so well that I must ask myself: To what does the sentence written in the painting relate? Do not look overhead for a true pipe. That is a pipe dream."[108] Foucault calls this an object lesson, reminding us that it's as much a lesson about things—*could you stuff this pipe?*—as it is as a lesson about poetry and pictures. This is not a thing. In fact, Magritte's title—*La trahison des images*—which recalls Julian Benda's *La trahison des clercs*, created the same year—points to the affective failings of the word-image as a ministry of things.

40

Stuffed or unstuffed, the pipe bowl—the jug, the container—alights. Consider, for instance, this object lesson about waste: a garbage can, carefully placed under the whiteboard in my classroom, and upon it, a sentence on a sticker, in pedagogical boldface: THIS IS ALL THE GARBAGE WE MAKE. What is the nature of this form of address concerning a container, I wonder. Is it a command? A form of self-congratulation? A categorical imperative? However passive aggressive in intent, does the can advertise its wish or its capability? Emphatically, like Magritte's painting, it seems to announce, at threshold of its legend, as it were, a bar across the fortunes of non-things and our desires to un-riddle them. This is where things are decommissioned back into objects, the non-thing says. In fact, this is a ruse; this is merely another risk destination, an occlusion where non-things are placed out of view by a strange catechism of sophistry. As part of the same campus initiative, another yet smaller plastic container appeared on my desk, a miniature green garbage can.

The slogan on the "Mini Bin," "This is all the GARBAGE I make," is a constant reminder to recycle more and produce less garbage, according

FIGURE 33. "This is all the garbage I make!"—photograph by author.

to the elaborate directions that accompany it. The very smallness of this canister—that it sits on (not next to) my desk, that the directions tell me to empty it into yet another container located in the men's room, suggests that this novelty item is framed by the risk positions of second modernity. The can is the designated totem for my becoming minimal— for reducing the impact that is me.

39

The can's overt proposition is belied not only by the multiplication of other containers it implies like so many telescoping cups, but also by gears of commerce set into motion by my employers to extract wealth

from my proposed sorting of my own by-products. This very non-thing on my desk does not so much disclose itself as it dresses-up a telescoping sequence of risk propositions for further administration as a kind of gift. The FAQ, for example, includes this fallacy of presumption dressed up as call and response:

> Q: What if my desk is already too small and cluttered?
> A: If someone gave you a box of chocolates to sit on your desk, you'd find space for it, wouldn't you?[109]

Items for the trick mini-bin include "soiled tissues and napkins, apple cores, banana peels, foil lined snack bags, candy bar wrappers."[110]

These mixed materials are not so much essentially harmful as they betray the characteristic chain reaction of the uncertainty of risk epistemology, because they can't be cleanly disaggregated: laminated foiled papers too expensive to sort, dirty tissues and napkins too contaminated for further processing. Items for the bigger container are so designated not because they can intrinsically be returned to the state of objects— but because they can be further monetized. Doing something is better than nothing, unless nothing is already the only something we have.

38

Take, as a last thing, a plastic bottle. This one that sits before me as I write, for instance. The very sort that whirls around in the great Pacific trash vortex. The ones Kevin Costner drinks from in *Waterworld*. What is its message? The fact that it towers over the mini-can tells me that it's not fit for that impossible green enclosure. It belongs in the container we share in the hallway; it's garbage fit for reprocessing. And, on the bottle, there is another legend of the novelty item, a self-congratulatory bit of news about its lid:

> Smaller Cap = Less Plastic
> Did you notice this bottle has an Eco-Slim cap? This is part of our ongoing effort to reduce our impact on the environment. This bottle and cap contains an average of 20% less plastic than our original 500 mL Eco-Shape™ bottle and cap. Be Green.

And, beneath this announcement, another warning about new risks:

WARNING: Cap is a small part and poses a CHOKING HAZARD, particularly for children.

FIGURE 34. Choking Hazard—photograph by author.

Risky Things

37

Risky Things. For a recent, real-life version of this fable—novelty without waste, or gain without risk—it would be hard to improve on No Impact Man. In early 2007, his story swept through the media. Somewhere in Manhattan, the story ran, a writer and his family were contriving a way to live having "no impact" on the Earth. To counteract the greenhouse catastrophe, they adopted a total do-it-yourself ethos. They no longer bought things—except provisions at the farmer's market produced "within 250 miles—a day's round trip."[111] For light, one bulb supplemented by beeswax candles. Every deprivation becomes a kind of gain. To minimize waste, vermicomposting the food scraps, toting receptacles made of natural materials, hand-washing diapers using "ethical" cleaning concoctions. In short, all the consumer perks were forsworn, everything contributing to the carbon footprint verboten or compensated for with donations to environmental charities and carbon-trading schemes.

36

German sociologist Ulrich Beck's theory of second modernity can help us understand this behavior. No Risk Man can be seen as a paragon of Beck's "risk society."[112] For Beck, the decisive shift between the two modernities entails a transition of cultural logic from wealth distribution (or "goods") to risk distribution (or "bads"). Modernity stops being about extending the benefits of detraditionalizing modernization and instead becomes reflexive. It increasingly becomes "its own theme," concerned not with instrumental rationality but with managing its own ambivalent side effects, "discovering, administering, acknowledging, avoiding or concealing . . . hazards."[113] In short, an epistemological New Deal: knowledge retains its cardinal powers, yet, as seemingly "harmless things, wine, tea, pasta, etc., turn out to be dangerous, the status of knowledge subtly and irrevocably changes. . . . The once highly praised sources of wealth (the atom, chemistry, genetic technology and so on) are transformed into unpredictable sources of danger."[114]

35

The case for second modernity, then, depends on two observations about time and space, which should be of special interest to readers of Richard Powers's novel *Gain*. Contaminated relations detected in the everyday experience of things implicate experiences of the past and present and relations of the bodies insides and outsides.[115] Risk shreds promissory notes of cause and effect with wide-ranging, new, and frequently paradoxical implications for identity, society, and politics. Beck underscores that "the center of risk consciousness lies not in the present, but in the future. In the risk society, the past loses the power to determine the present. Its place is taken by the future, thus, something non-existent, invented, fictive as the 'cause' of current experience and action."[116] Under first modernity, the past determines the future. Yet, if the modernist break with tradition is the arch form that consciousness takes under first modernity, in the second release, the idea of the present as a leave-taking of the past itself becomes passé. The present is now (over)determined by the future.

34

A Tale of Two Soaps. It seemed not too long ago that every academic critic worth her salt needed a theory of *Fight Club*. Either the David Fincher film or the Chuck Palahniuk novel sufficed. Properly speaking, this one is an anti–*Fight Club* argument; Powers's *Gain* is almost perfectly anti-Palahniukian. The reason *Fight Club* may make fine whetstone for criticism is not so much that it has been thoroughly hashed over by would-be critics but that it comes with a ready-made thesis in tow. In the case of *Fight Club*, the message is that the individual is fragmented—or, maybe just feminized—by commodity culture. Homosociality cum blood sport can repair the commons. The fist in the face heals the whole earth. *Gain* rejects this pseudo-utopian thesis out of hand—the role of the individual consumer in the corporation is damage, complicity, exposure to risk.

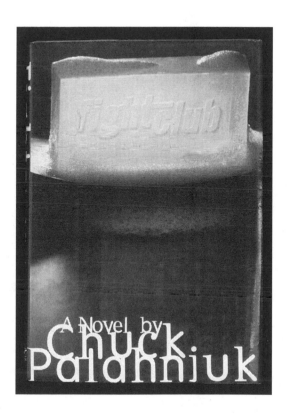

FIGURE 35.
Soap I—First edition
cover, Chuck
Palahniuk, *Fight
Club* (New York:
Norton, 1996).

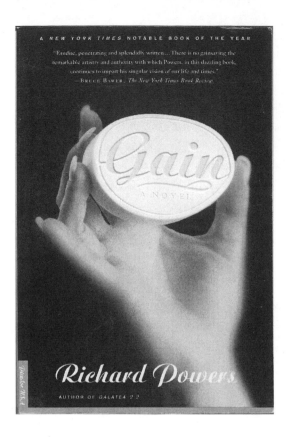

FIGURE 36.
Soap II—Paperback
cover, Richard Powers,
Gain (New York:
Farrar, Straus, and
Giroux, 1998).

33

On the film poster, the contrasting soap presentation is more pronounced. The man hands—to wit, Brad Pitt's bruised knuckles—holding an oddly pink cake, the same color as Wyndham Lewis's avant-garde magazine *BLAST*. Tag-line: "Mischief. Mayhem. Soap." Soap plays a key role as a symbol. In *Fight Club*, "making soap" means revolutionary DIY lifestyle, cleansing, self-rendering. Tellingly, Pitt's pose holding a bar of soap echoes the flashing of a badge; it is an initiation, a secret handshake. Pointedly, in a critical episode, he teaches the narrator to make soap, using, in the movie anyway, liposuctioned fat. This is an inset detail: soap equals purgation. The connection depends on semiotic similarity. The alternative, underground, economic logic points to any number of anarchist's cookbooks: "With enough soap," Tyler says, "you could blow

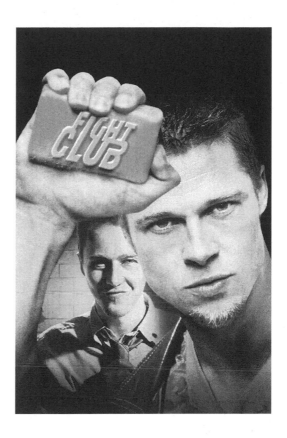

FIGURE 37.
Soap III—Poster,
Fight Club, dir. David
Fincher, 20th Century
Fox, 1999.

up the whole world."[117] Soap is explosive, cleansing the individual of consumerist corruption: Soap means something else to us—Tyler tells Project Mayhem—it is a symbol of our shared project.

32

Compared with symbolic soap in *Fight Club*, soap in *Gain* is allegorical: a full blown illustration, a metonymy, contiguous with the rise of the corporation that sells it and then does not. Before it is Clare International, it is Clare Candle and Soap Corporation. The substance of soap in *Gain* is also the substance of the issue. As one of the many extraneous sections in *Gain* puts it: "Soap is a desperately ordinary substance to us. It is almost as omnipresent as air and water. It is so common that it is difficult to imagine life without it . . . Not until modern industry came

along to demonstrate the virtues of mass production did soap become the property of all the people."[118] Like *Fight Club*, *Gain* includes a detailed discussion of the soap-making process:

> Here was a substance, grease's second cousin. Yet something had turned waste inside out. Dirt's duckling transformed into salve's swan, its rancid nosegay rearranged into aromatic garland. This waxy mass, arising from putrescence, became its hated parent's most potent anodyne. . . . To make their first run, they paid cash for a quantity of fine rendered fat. Thereafter, they sought suppliers who would trade good tallow for excellent soap, a pound for a pound. As their process made two pounds of soap for each pound of introduced fats, they would have half their run left over to pay for alkali, keep equipment repaired, and put bread on their own tables.[119]

The multivalent word of Powers's title—gain—may find its most straightforward application in this passage. *Gain* is the winnings, the supernaturally profane increase, which, other than God, only the corporation is positioned to make scalable for its constituent parties and shareholders. In *Fight Club*, where the corporation is merely symbolized by skyscrapers, this kind of transaction is not so much narrativized as it is displaced; indeed, the organizational gain, its incorporation and complexification, is not rendered in terms of a soap imperium but in terms of *Fight Club* franchises.

31

For what it is worth, Powers's original soap-maker, the Irish immigrant Ennis, has all the preternatural knowledge about soap making, but he is not able to go it alone without backers. He is an expert; he is also significantly a melancholic idealist. If not Tyler Durden or No Impact Man, somehow in the soap maker's fraternity he is a distant relation, a far more enigmatic figure than the early Clares, surely, because of his connection to scientific know-how. Ennis just wants to sell a perfect object that he knows how to make, which, it seems, is also an impossible commodity—a bar of soap that costs more to make than he gets for it: "a perfect soap that you could go and sell below cost."[120]

30

The magic of soap is not simply the technical knowledge of chemical engineering—better living through chemistry. It is the sleight of hand of a perceived gain without visible risk (from sin to skin cleansing) otherwise described as the impact of consumer engineering.[121] You know, better living through marketing:

> Only when Resolve [Clare] gazed upon that first [batch of finished soap] did he consider their odd position. Their own customers would be their chief competition. Caked soap was still an expensive substitute for the slippery paste that every home could yet make as a matter of course. The Clares' soap had to teach thrifty New England how smelly, difficult, and undependable home soapmaking had always been.[122]

So, unlike in *Fight Club*, the stuff you don't need, the manufactured "needs" that the hidden persuaders foist on you, aren't IKEA chipboard end tables—mere symbols of an abstract consumerism; it's the altered epistemological status actually carried by a real thing, namely, soap. Powers frames this scene—the primal scene of the presentation of soap, as it were—precisely as an occasion of epistemological loss, a process through which technical knowledge (i.e., the household knowledge of making cheap cleansers) is lost. The story of the Clare Corporation is a gain wagered on less knowledge about how things are made, how they work, what they may or may not do to you.

29

Gain as a novel is, quite fittingly, more than the sum of its parts. Basically, its parts are two narratives—neither of which is typical substrate of great novels. Place this brundlefly in a teleporter to disentangle, and neither of the generic threads would survive long. The first concerns the rise of the Clare Corporation; the second concerns the decline of Laura Rowan Bodey, a single divorced woman diagnosed and unsuccessfully treated for ovarian cancer. Generically, the parts derive from biography-like nonfiction forms: the corporate history/commodity bio and the cancer memoir, respectively. The parts alternate and are separated by a

thin diacritical lozenge—a soaplike sliver separating the generic constituents. Neither part is epistemologically sufficient.

28

The third element, then, is all the extraneous, expositional stuff, scraps of information, waste, signs, advertising, research, adding to this sense of narrative insufficiency. That is, a key piece is missing—a lost reel from both narratives, which is, simply put, the scene of critical, epistemological contact—fateful and fatal—between the first narrative and the second more than the coincidence of their shared time in Lacewood, Illinois, where Clare has a manufacturing plant. That linchpin moment of contamination of the individual by the evil corporation (familiar enough from *Silkwood* to *The Incredible Shrinking Woman*; *Spiderman* to *Michael Clayton*) is, tellingly, left unnarrated. When did it happen to her? Not even a court ruling does the trick, because it is a class action. Risk is only adjudicated as it is measured: in aggregate humanity. "As the pamphlets say: the numbers stand for groups, not for individuals. . . . [M]aybe it means, repeat the next five years forever, and on average, a fifth of her will die."[123]

27

The unlikelihood of both novels as novels goes back to the situations of their organizing agents. First, a post-human body made indestructible by law: it "far outstripped the single life's span."[124] "Enterprise's long evolving body now assembled good beyond any private life's power to manufacture."[125] Powers makes this point emphatically:

> The law now declared the Clare Soap and Chemical Company one composite body: a single, whole, and statutorily enabled person. . . . If the Fifth and Fourteenth Amendments combined to extend due process to all individuals, and if the incorporated business had become a single person under the law, then the Clare Soap and Chemical Company now enjoyed all the legal protections afforded any individual by the spirit of the Constitution.

And for the actions of that protected person, for its debts and indiscretions, no single shareholder could be held liable.[126]

26

Second, a single, female body, made low by hidden causes, causes sus-
pected to be linked to either a life spent in Lacewood and/or one of
many consumer conveniences provided by Clare or one of its competi-
tors. In this sense, Laura Rowan Bodey—her ex-husband calls her "lo"—
a lowly, ruined body, is the individual human as a net loss, eventually
reduced to materializing her failing chemo-addled mind with Post-it
notes. Neither of these two entities—and I realize it is distasteful to de-
scribe Laura in these terms, but I am convinced this is Powers's point—is
possible as a protagonist. It is decidedly not a novel about a woman ver-
sus a corporation. Neither one has so much a comprehensible struggle—
agon in the classical sense—as a contrasting risk position. The sum of the
parts is no more and no less than the dual disclosure of their respective
risk positions: the corporation is an entity with aggregated risk security,
and an individual is an entity with absolute risk exposure. The normal-
ization—or, routinization—of risk in the corporation is counterposed
to a position of absolute exposure to risk, a position in which risk is so
widespread that it is literally the water she swims in.

25

The corporation is shown to have no malice for Laura. Indeed, if it is
not exactly indifferent to her life story, it sees itself twinned with her fate:

> Clare, with its allies Lever, Colgate, and Proctor and Gamble, scrubbed
> out of existence those German and Jap cottage industries that hoped to
> convert the world to soap made from unspeakable sources. Clare Soap
> and Chemical won the war. . . . Or rather, Mrs. Consumer did. She won
> in the pantry and on the stove top and in the medicine chest.[127]

Back to those feminine hands with French manicure, presenting the bar
of soap to herself. Implicated in an advertising feedback loop cum death
cult, the identification between Laura and Mrs. Consumer is mutual:

> Laura reads [*Shopping for Safety*] in tiny increments, in those moments
> when her head is clear and her eyes can focus. As far as she can make out,

nothing is safe. We are all surrounded. Cucumber and squash and baked potato. Fish, that great health food she's been stuffing down the kids for years. Garden sprays. Cooking oils. Cat litter. Dandruff shampoo. Art supplies. Varnish. Deodorant. Moisturizers. Concealers. Water. Air. The whole planet, a superfund site. Life causes cancer.[128]

Here, she is also a cognate of the wife of Ennis, the early Irish soap maker, who dies during the passage to America. The moment of Clare's investiture as business enterprise—a collective activity—pays for the coffin of one dead wife. It is an ambivalent legacy.

24

This continuity is one of the reasons I think it is a mistake to read the soap bar as a symbolic warning of corporate wrongdoing. Another is this passage:

> The newspapers, Don, the lawyers: everybody outraged at the offense. As if cancer just blew in through the window. Well, if it did, it was an inside job. Some accomplice, opening the latch for it [. . .]. She brought them in, by choice, toted them in a shopping bag. And she'd do it all over again, given the choice [. . .]. No longer her home, this place they have given her to inhabit. She cannot hike from the living room to the kitchen without passing an exhibit. Floor by Germ-Guard. Windows by Cleer-Thru. Table by Colonial-Cote. . . . She vows a consumer boycott, a full spring cleaning. But the house is full of them. It's as if the floor she walks on suddenly liquefies into a sheet of termites. . . . Clare hiding under the sink, swarming her medicine chest, lining the shelves in the basement, parked out in the garage. Piled up in the shed. . . . Her vow is hopeless. Too many to purge them all. Every hour of her life depends on more corporations than she can count. And any spray she might use to bomb the bugs would have to be Clare's, too.[129]

23

The message in *Gain* about the calculus of risk is chiefly epistemological. It is what we think we know about the unknown that counts: "People

view themselves simultaneously as part of a threatened world and as part of their local situations and histories."[130] Although the knowledge this involves is not exclusively ecological—it is also economic and terroristic— future ecological catastrophe may be understood as its governing theme. Risk—something that is not stable in terms of knowledge—becomes a general theme of knowledge. Postmodernity presupposes epistemological uncertainty, second modernity does not. The subject to risk is not a postmodern hero—not a subject of postmodernity as it is frequently construed in terms of epistemological uncertainty or ethical relativism. She feels subject to threats that her lay knowledge cannot adequately access but feels a categorical imperative to address them. Nor is she not anti-science. She cannot be. Her knowledge of threats requires "the 'sensory organs of science'—theories, experiments, measuring instruments— in order to become visible or interpretable as threats at all."[131] Donald Rumsfeld's much ridiculed remark about "known knowns, known unknowns, and unknown unknowns," concerning military risk in the second Gulf War, applies here as a critical idiom. As Beck puts it: "Unknown and unintended consequences come to be a dominant force in history and society."[132] The invisible threats—toxins, radiation, CO_2, inflation, invisible enemies next door—are not private risks experienced in the present, but socialized risks to be or not to be experienced, known unknowns and unknown unknowns that may or may not be deferred in the future after one's death.

22

Home Alone. The basic, assumed human unit in second modernity is neither nuclear family nor the childless couple but the single person.[133] While Beck describes children as "the last remaining, irrevocable, unexchangeable primary relationship," he also notes that they do little more than facilitate the individual's exposure to risk. In fact, individualization, for Beck, has not so much to do with consciousness or identity formation in the romantic sense, nor does it really follow from employment position. He equates it instead with what he calls "the objective life situation"—which is something like orientation toward employment.[134] Here is one last image of a hand, a fingertip presenting the trademark fleck of cleanser.

MARCH 2008

jobpostings

JOBS & GRADUATE PROGRAMS FOR STUDENTS

Brand You®

What You Have in Common with Oprah and Beckham

Insider Tips to Ace Your Interview

Co-op vs. Internship

■ Trends in Healthcare

■ Government and Military Training Programs

jobpostings.net

10 years
helping students

FIGURE 38. "Brand You"—Magazine cover, *Job Postings* (March 2008).

Individualization means the social separation of adults from others (parents, school ties, etc.), "the variation and differentiation of lifestyles and forms of life, opposing the thinking behind the traditional categories of large-group societies—which is to say, classes, estates, and social stratification."[135] Paradoxically, the moment of individualization also represents the defining scene of socialization:

> The individual himself or herself becomes the reproductive unit of the social in the life-world. What social is and does has to be involved with individual decisions. Or put another way, both within and outside the family, individuals become agents of their educational and market-mediated subsistence and the related life planning and organization. Biography itself is acquiring a reflexive project.[136]

21

A single, solitary unit enters a labor market that above all demands mobility and flexibility. And, given this market's dependence on "flexible, pluralized underemployment" and demographics (discussed at length by Beck) that tend to situate women in this profile, Risk Woman may in fact be a more accurate gender designation. In short, the market requires her to adopt a risk position.[137] The substance of this social reality is liquid, resembling Zygmunt Bauman's liquid modernity: a connection Beck has recently acknowledged. Her education remains a critical locus for second modernity, the very reason education serves as the best means of achieving a favorable risk position is because it creates human liquidity.[138] Like Simmel's money, educational credentials loosen local ties and enable biographies to be composed on a colossal scale via nonlocal networks: "By becoming independent from traditional ties, people's lives take on an independent quality which, for the first time, makes possible the experience of a personal destiny."[139]

20

And, it is thus not surprising that the figure of Laura—dying of a cancer that may or may not be caused by the biographical proximity to Clare's corporate history—provides a paradigmatic example for this process.

Indeed, the following passage of Beck's is striking not only because it simultaneously overvalues and undervalues the individual biography but also because it provides a rather perceptive description of the modernist author function:

> All [the] experts dump their contradictions and conflicts at the feet of the individual and leave him or her with the well intentioned invitation to judge all of this critically on the basis of his or her own notions. With detraditionalization and the creation of global media networks, the biography is increasingly removed from its direct spheres of contact and opened up across the boundaries of countries and experts of a long-distance morality which puts the individual in the position of potentially having to take a continual stand. At the same moment as he or she sinks into insignificance, he or she is elevated to the apparent throne of world-shaper.[140]

This is none other than the predicament of No Impact Man, elevated to the apparent throne of world-shaper as he sinks into insignificance. Tellingly, it also captures the aim of his No Impact project: the epic side of doing nothing. The following statement, which is nominally about one of his project's many moments of self-doubt, effectively individualizes this sentiment in all its vertiginous impossibility:

> I get confused. If everybody on the whole planet decided to commit suicide, which in a way, they have, would it be the right thing to do to not join in? What's so great about trying to be right if it keeps you separate? It seems like there is something precious that has to do with holding yourself above or not just joining in and being part of. I don't know. I'm suddenly realizing that this whole [No Impact] project could be pretty damn hard.[141]

19

In this vein, Raymond Williams's famous essay "Culture Is Ordinary" (1958) provides an apt point of comparison with No Impact Man's discourse. It offers a midcentury critique of the cultural idiom of modernity—not "angry" (in an all too diffuse "Angry Young Men" vein) but

not yet "reflexive" either (in Beck's sense). Without getting into too much detail—or doing any real justice to Williams's evocative attempt to imagine cultural value across class difference—let's focus on Williams's synthesis between two senses of modern culture: one, instantly descriptive, anthropological ("a whole way of life—the common meanings") and the other, doggedly prescriptivist, axiological ("the arts and learning—the special processes of discovery and creative effort."[142] Using the playbook of first modernity, he then describes the cultural past in terms of tradition ("known meanings and directions, which its members are trained to") and the cultural present in terms of experiment ("new observations and meanings, which are offered and tested").[143] The thing is: the two pairs don't correlate in an either-or fashion for Williams. *A whole way of life*, and so forth, provides contexts for *discovery and creativity*, and so on, but it also depends on the *known* for its frame of reference about what part of the *new* does cultural good. This last point is a professed debt to F. R. Leavis (not for nothing is Williams called by Eagleton a "left Leavisite"): to reject what Leavis describes as the techno-Benthamism of a new commercial society in which the idea of good comes with the "exclusion of [any] ethical content and [with] emphasis on a purely technical standard."[144] *Good* becomes recognizable only in the commercial language of a *good time*, a *good show*, and so on. Williams's formulation registers paradoxes and ambivalences about this and other matters, certainly, but never abandons the idea—as Leavis does—that modernization brings good/goods:

At home [in the Welsh border country] we were glad of the Industrial Revolution, and of its consequent social and political changes. True, we lived in a very beautiful farming valley, and the valleys beyond the limestone we could all see were ugly [due to coal mining]. But there was one gift that was overriding, one gift which at any price we would take, the gift of power that is everything to men who have worked with their hands. It was slow in coming to us, in all its effects, but steam power, the petrol engine, electricity, these and their host of products in commodities and services, we took as quickly as we could get them, and were glad. I have seen all these things being used, and I have seen the things they replaced. I will not listen with any patience to any acid listing of them—

you know the sneer you can get into plumbing, baby Austins, aspirin, contraceptives, canned food. But I say to these Pharisees: dirty water, an earth bucket, a four mile walk each way to work, headaches, broken women, hunger and monotony of diet. The working people, in town and country alike, will not listen (and I support them) to any account of our society which supposes that these things are not progress: not just mechanical, external progress either, but a real service of life.[145]

Williams is eager to drive home that working people are the first responders to technical modernity—the vanguard best placed to assess and make meaning of modernization's invented improvements to a whole way of life. The formula for Williams seems far away from the sustainable agrarian idyll that No Impact Man dreams up downtown. For Williams, the "gifts" of the market society (which Tim Dunlop updates to include "the advent of the new communications technologies, of the internet, the cordless phone, the DVD, as well as two minute noodles, eftpos and Wet-Ones")[146] are so overwhelming that they "override" the quietly murmuring side effects signaled by the spoiled valleys up the road and over the horizon. In fact, more than the inevitable decline of old industry, it's Williams's presence—or else, his absence—in the rural community that may matter most. "Market forces do not create the conditions for good and stable communities because they demand loose attachments and shallow roots," as Dunlop puts it, including the poignantly loosened attachments and general uprootedness that implicate Williams's biography as Williams describes his return bus journey over distances created by his educational and professional credentials for his father's funeral.[147] Here, the framing bus journey for the essay takes on a little more weight. Like all the dry-cleaning bags, filterless cigarettes, and missing seatbelts of *Mad Men*, the pre–catalytic converter bus ride provides a ready-made emblem for the knowledge of our own risk-challenged futurity. The bus—and all that mechanized power experienced as gift, to leave for universities and for cities, to leave the defining rubric of class—is, in a sense, an emblem for the power of the risk society's new deal concerning knowledge and the biographical individual. And, its latency in first modernity. It's there, but Williams doesn't know about it, yet. He represents, in effect, the invisible, unknown risk borne by biopower.

18

Dare to Know the Risks. No Impact Man, for what it is worth, approaches his project with an autodidact's zeal for designing and describing experiments. He is constantly soliciting information to these ends from the web equivalent of the *Whole Earth Catalogue.* "Of course," he blogs, "the scientists will tell you that [no net environmental impact] doesn't work, but it isn't intended to work so much scientifically as it is to work philosophically."[148] And, as the comments on the site so often document, the scientists do take issue with the science. Here, the specific problem that No Impact Man has in mind is, I think, the futility of the urban dweller of the global North (even in their collective efforts) neutralizing the great carbon offense of our time, the hydrocarbon economy in all its unconstrained, coal-powered productivity. Scientists alone can't tell you this, though. Neither can political policy wonks, nor economists, nor any single professional knowledge expert, including philosophers. They can't resolve this "interdependency crisis" between ecological, economic, and terroristic domains. The claim that the project is driven by philosophical motives is not that it turns out a saving framework but a related story.

17

The philosopher proper who comes up most prominently on the No Impact Man site is Kant:

> Now I am no expert on philosophy, but my friend Eden tells me that Kant considered the best test of morality to be the Formula of Universal Law. He wrote, "act only on that maxim whereby you can at the same time will that it should be a universal law." Or to translate, each of us should live our lives in such a way that would allow for the possibility of everyone one else living the same way. Assuming I was like the average American before the No Impact experiment began, my ecological footprint was 24 acres. But worldwide, there exist only 4.5 biologically productive acres per person. In other words, if everyone were to live like the former me, we would need more than five planet earths. So, there was no possibility of everyone else in the world living the same way as me. Kant would have thought I was immoral. He would have smiled upon the No Impact project, however, Eden says.[149]

In essence, No Impact Man reaches out to his virtual readership for philosophical cover for the same point he makes regarding the project's acknowledged scientific shortcomings. Indeed, this curiosity simply shows what philosophical grounds and policy implications are wrapped up with the scientific claims he initially draws on, which were always underwritten by a tacit version of Kant's categorical imperative as it informs the use of knowledge and reason. Dare to know the hidden risks. Don't take more than you use—more than your own ecological offset—means also conceiving of your actions in terms of the fashioning of a universal law for perpetual ecological sustainability. Yet, because consumption equates to waste, don't waste more than you use is the more appropriate if a bit perplexing formulation. You waste more than you use because you are wasting for others. With the rule of side effects, you are always in effect using the offset of others elsewhere, both spatially and temporally. "To act like your actions were passing laws in the ideal kingdom[,] the kingdom of ends," as one of No Impact Man's respondents put it, means affecting a favorable risk position that operates for all possible outcomes for everyone—down to the nonrational agents, as Beck would have it in a moment of Hobbesian flourish: "In this struggle of all against all for the most beneficial risk definition, to the extent that it expresses the common good and the vote of those who themselves have neither vote nor voice (perhaps only a passive franchise for grass and earthworms will bring humanity to its senses)."[150] A whimsy that signals perhaps we have changed horses from the epistemological/ethical concerns of the First Critique to the reflexivizing aesthetic concerns of the Third Critique.

Aesthetic modernity is Scott Lash's cognate term for Beck's second modernity: "The second and importantly aesthetic modernity is not anti-rational or rational but has a principle of rationality based on reflexivity."[151] Considering this we might better understand No Impact Man's use of the term *philosophy* to mean philosophical cover for an aesthetic of biography. What he probably means by "philosophy" is "personal philosophy," that folk psychological commonplace. Perhaps, his question is better put thus: Does the project work biographically? Can No Impact Man tell himself a story that he can live with ecologically? The biographical identity of No Impact Man, as we have seen before, is an irreducible aspect of his project. For his recipe to work in all spaces and

times—and I mean this not a bit facetiously—everyone would have to have a book deal in the wings. Can we then speak of a text-production-consumption offset scheme, 4.5 interpretively productive writers per reader, say? Finally, it is the consciousness-raising potential of the project that justifies its philosophical and scientific shortcomings and indeed the excesses of its extremes.

16

Beck writes that "in class and stratification positions [that ruled first modernity] being determines consciousness, while in risk positions [that dominate second modernity] consciousness determines being."[152] So it is with No Impact Man:

> During the course of the year, Michelle, Isabella and I will traverse the range of lifestyles from making a limited number of concessions to the environment to becoming eco-extremists. This means that when we're done, we can reenter the world of normal consumerdom equipped to decide which parts of our no impact lifestyle we're willing to keep and which ones we're not. In other words, in addition to the no impact year, we'll have figured out our way forward.[153]

Is eco-Kant still smiling? This our/we could be certainly read as the restored universal pronoun that Jean-François Lyotard said failed—the risk society serves as a kind of the return of the repressed for metanarrative. Another, more literal reading is that the *we* here is, strictly speaking, No Impact Man, his wife, his daughter, and his dog. The two possibilities are, of course, related, if you accept the terms of No Impact Man's project and given that the family unit more often than not plays the part of unenthusiastic bystanders to subjectivization in the risk society.

Materials and Their Methods
15

Materials and Their Methods. Felt. Blood. Fat, wax, honey, gold leaf. *A Rubberized Box.* Well-thumbed lapin fur in mottled hues. A hare's inert body, cradled by the artist. The mere inventory of the materials

employed in artwork of Joseph Beuys—across three decades of actions, installations, performances, and documentations and still going on now nearly two decades after his demise—is enough to conjure forth his name. There is a remarkable durability in the bundling of "Beuys" (as aesthetic imprimatur) to the very stuff in, from, and by which he fashions his aesthetic projects. This enfolding of felt material and method as Beuys's signature provocation. The man in the *felt hat* is not merely highly particular about material in his work; the conspicuous and deliberate attention to material is one of Beuys's signature provocations: What affective, stylistic, autopoetic, psycho-reflexive potentialities inhere in the stuff that things are made of: animal, vegetable, mineral; un-living, living, dead and undead alike? "The outward appearance of every object I make," Beuys says, "is the equivalent of some aspect of inner human life."[154] In the folding of diverse materials—Beuys's care packages—art arrives at the nexus of its very different spatial-temporal material modalities, which, as Beuys's critical summa, is an event he annotates for acute pedagogical possibility.

14

FIGURE 39.
Still-Life of Game—
Jan Weenix,
circa 1700.

Explaining Pictures to a Dead Hare. I'm wondering if it is harder to explain them to the living. I'm thinking of *How to Explain Pictures to a Dead Hare*—the title of Joseph Beuys's 1965 action, performed as a closed-door, gallery event in Düsseldorf, *Wie man dem toten Hasen die Bilder erklärt.*[155] The surprise is that the hare being, first, dead and, second, an animal isn't doubly indifferent to pictures. Of course, this may or may not be the point: animals, dead or living, humans dead or living. Muffled and mute, insulated and deadened from consciousness, how do we explain pictures to any of them?

For my dozing cat the television feels warm—a felt tube. *Filz-TV.*

FIGURE 40. *Filz-TV,* Joseph Beuys. Photograph by Lothar Wolleh; copyright Oliver Wolleh, Berlin.

It just represents a warmth, perhaps. But maybe animals are not always so dampened to pictures. The legendary Greek painter Zeuxis painted pictures so lifelike that birds were fooled into trying to eat the painted grapes. This is how animals seem to think about pictures—in myth, at least—if thinking is the right word. Or, how we explain pictures to them. Which is to say, how we do "something to do with thinking"—to use a Beuysian circumlocution—about art by first pretending to do something about it with animals. There are, of course, those ubiquitous stickers on glass so popular in Europe, featuring a silhouette of imaginary hawks. The homoeopathic talismans meant to signal something to birds: namely, keep out.

FIGURE 41.
Bird Silhouette.

They aim to keep real birds from careening into our dwellings by fooling them. To explain pictures in the nonhuman world is to *fool* it into understanding the artificial materials of an alien world, the messages of our materials. One must speak a language animals can understand— how to eat and how to be eaten. Here, we may find the deep scales of intelligence, the education of felt things, that Beuys invites us to seek. Lacan references the fabled painting competition between Zeuxis and Parrhasius in his eleventh seminar.[156] Parrhasius wins the contest by painting a curtain—a textile trompe-l'œil—that fools even the masterly Zeuxis into desiring to peer behind it. Buttocklifting, as Prof. Beuys puts it on his *Aushangsschild*:

Prof. Joseph Beuys
Institute for Cosmetic Surgery
Speciality: Buttocklifting

THE WAY THINGS GO

So, whereas Z is a master of mere animal verisimilitude—a maker of lures and decoys—P has mastered human desire, Lacan tells us.

13

The Artworld. The Zeuxis and Parrhasius story is also instructive about the institution of art, a fable about consumption and taste. P wins the prize not of making the most beautiful pictures but for besting the in-group, the experts. After all, P tricks the expert eyes of Z, the artist, whereas Z only fools the non-artist eyes, the animal eyes. In fact, it can be said that neither P nor Z competes in the arena of beauty, only in making images fit for consumption. Z fails because he is too slavishly literal about the culinary side of taste. He not only makes foodscapes look so tasty that they want to be eaten; he also seriously misreads his audience who are not birds after all. In the aviarium, Z wins, but, in this contest, it doesn't matter that the birds don't register P's curtain at all. So much for explaining pictures to animals. What of dead animals? Explaining pictures to a dead hare, that is. The dead have significance to the living. In other words, this is also a fable about representation contra signification, the difference between associations that depend on resemblance and associations that are dependent on a time scale in which accidental associations are reinforced—made into dead metaphors—by aggregate conspiracies of experts and institutionally fabricated contexts.

12

7000 Eichen (1982). Seven thousand oak saplings; seven thousand boundary stones of basalt in a field outside Kassel, Germany. For each sapling planted, a boundary stone is taken from the field and deposited at the tree's base. All this auto-associational processing occurs on longer scales than comprehensible within a single human life span. It projects thought . . . into a future age. Move your ass. Beuys: "After a number of years we will see a proportional equilibrium between stone and tree. And perhaps after 20–30 years we will see how the stone gradually becomes an accessory at the foot of the tree."[157] Culture and nature are both risk positions, in which the future has become determinant of the present. Maybe the rock is better fit for locking bicycles than the tree.

FIGURE 42. Poster for Joseph Beuys, *7000 Eichen*, documenta 7, 1982.

FIGURE 43. "Proportional equilibrium between stone and tree"—One of Beuys's seven thousand oaks, West 22nd Street, between 10th and 11th Avenues, New York City. Photograph by Noa Dolberg, 2013.

I I

Jannis Kounellis: Our culture is like an enormous plane tree. Every spring it sprouts new leaves. We're the leaves of this plane tree.

Beuys: I find this image of the plane tree interesting for its expressiveness. But today this tree does not produce [artists' works]; instead it produces electronics, atom bombs, philosophical knowledge, and medicine. The plane tree produces an enormity of things.[158]

For Kounellis, the tree is an image of creative renewal—there is one tree for art, one for medicine, and so forth. Beuys rejects this image: there

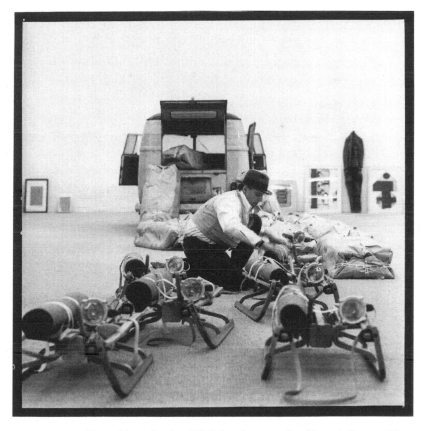

FIGURE 44. *Unpacking*—Lothar Wolleh, photograph of Joseph Beuys, *The Pack, No. 5*, Stockholm, 1971. Copyright Oliver *Wolleh*, Berlin.

is but one tree, a heuristic for creative thought, that verily produces atom bombs and hospital systems as it produces paintings and gallery systems. On the plane tree today—the one that emerges after the catastrophe, after World War II for Beuys—there are a few "interesting things," he says, but "90% of the [other] things are useless," and very few of the things are art. The point is not producing art objects—representations, images, and narrations of Beuysian actions—but producing, still translating Beuys, "a future interpretation of culture has to come not from the driving forces of the economy, but from a place [i.e., from a kind of art-situation] where *material is* an identity card for rights and duties and the *durchfilzen* [frisking] happens at the border-zone."[159]

10

How felt felts. Concerning the blanket in *I Like America and America Likes Me* (1974), at times covering Beuys, at times toyed and tugged on by a wild coyote, Beuys equivocates: "It's felt, that's right, real felt," he says. But, also: "Actually it's a blanket and not felt, an old horse blanket. Yes, these blankets have a woven structure."[160] The materials have their messages, felt or not, noiseless and dustless, they have their embassies.

Die Materialien und ihre Botschaft. Worn-out fabric that is woven can be fulled, but it is not felt—wool sweaters washed in hot water have a feltlike state but are not felted. Fulling differs from felting. Fulling is done to fabric, whereas felt makes itself and is not in fabric form. This is how the felt felts: the core of wool fiber or other mammal hair is covered with a cuticle sheath. When moisture enters this core, it swells it and pushes apart the surface layer forming cuticle-scales. Pressure and movements jostle the wool fibers. The established scales mean that the fibers can only move in one direction, and through this action the fibers get caught and associated more and more. Thus, felt is not woven or knitted by weavers or knitters but linked as a function of its own qualities.[161]

Fig. 3

Fig. 4

FIGURE 45. "Felt-roller"—Volker Göbel, Felting Apparatus, U.S. Patent 4,070,738, filed July 8, 1975, issued January 31, 1978.

9

Felt is a material that makes itself, under the right conditions, of course—water, heat, friction. Auto-associationally the fiber is fibrously self-bonding.

Fur stuffed in the end of wooden shoes at the beginning of the workday—to prevent raw toes, perhaps—comes out in the evening as something else fused by sweat, blood, and friction. One might imagine a primordial felt-making in a similar manner. Saints walking, padding their

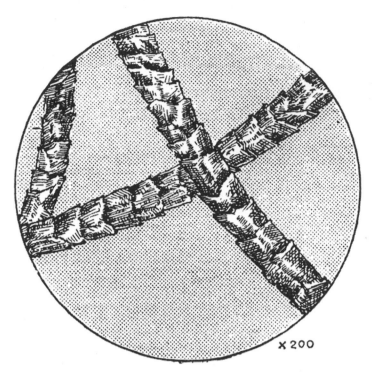

FIG. 5.—Microscopic appearance of wool fibres.

FIGURE 46. "Microscopic appearance of wool fibres"—H. Harper, *Introduction to Textile Chemistry* (London: Macmillan, 1921), 10.

FIG. 7.—Diagram to illustrate Theory of Felting. Interlocking of Scales.

FIGURE 47. "Diagram to Illustrate Theory of Felting, Interlocking of Scales"—H. Harper, *Introduction to Textile Chemistry* (London: Macmillan, 1921), 11.

sandals with wool to cushion their flights from persecution, and discovering at journey's end beside sore feet and blisters the miraculous creation of material. An anthropological meaning consecrated by all felt-making peoples, associations even more primal than the legacies shared by peoples who found ways to weave fabric. For the felt makers: do they feel that their discovery is the last gift of nature to culture? The talismanic archetype as mythic method for a cultural common culture? What-felt-means as such—in a universal anthropology, if such phrases are still critically permitted—is a concept that responsible criticism has long set aside, I think. Beuys-as-shaman of found objects feels too much like the Jungian mistake. Don't do it! The association of feeling and felt are no more than accidents—an accidental plane wreck of history—not reparative re-enchantments of the world.

8

Beuys, then. How did *he* feel about felt? What was it to him? What were his associations? The felt stores and insulates warmth and so, for Beuys, it creates "a kind of power station, a static action." There is a lot of such for-Beuys-ism in his critical reception, the notion that it's important to weigh what this or that means for Beuys, as if critics were tasked with solving a rebus of private symbols borrowed from the lost-and-found bin of an artist's individual life. His Stuka crashes in the Crimea. His wounded body was smeared with grease and wrapped in felt by nomadic rescuers. These wrapping materials healed him. In the self-authorizing myth, at least, Beuys represents the last exemplary real personality.

FIGURE 48.
Beuys Sled—Drawing by
Patrick Odom, http://
www.patrick-odom.com.
Copyright Aaron Jaffe.

7

Or, as Robert Hughes called him, "the last man to become a . . . celebrity through the machinery of the art world." His work, Hughes writes in a *Time* retrospective,

> is so wrapped in personal myth that it all looks equally good to his devotees. To those who are less committed, it seems very uneven. His stacks of felt rectangles, topped with copper or iron plates, have the dumb, disengaged look common to most minimal art. It does not help much to learn that the slabs of felt are meant to resemble the plates in a wet-cell battery; no current runs, and inertia is inertia. His most extravagant object—20 tons of mutton fat cast into the form of a corner of a pedestrian underpass . . .—was meant as a critique of heartless urban landscape, but its own megalomania crushes the small point it makes. On the other hand, Beuys is brilliant at using laconic, coarse, gritty, abandoned things to suggest a tragic sense of history. A case in point is his dreadful reliquary of Auschwitz . . . its few objects in a glass case—blocks of fat on a battered electric hot plate, moldering sausages, a mummified rat on a straw bed, a diagram of the camp, a drawing of a child—are perhaps the most poignant, and certainly the least exploitative, image in modern art of that catastrophe.[162]

To Hughes, Beuys, who chucked away the artifactual art object once and for all, feels like the heroic artist's reputation pars pro toto. Accordingly, his actions are represented as deadening placeholders for art, stepping in to a breach where real personalities used to be—a dumb, disengaged look common to the most minimal aesthetic act; an extravagant gesture overtaking a banal moral about the idiocies of urban planning; a surprisingly apt collection of filthy things. Arthur Danto writes that "Beuys is often thought of as if he were someone influenced by Beuys."[163] As if wrapping it in felt, celebrity organizes nostalgia for some one particular feeling—what Beuys feels—on a general, planetary scale.

6

Thinking with Beuys. Thinking in the art-critical mode often means an exercise in decoding the private rebus, and thinking the art-historical mode often means tracing influences—the golden chain linking Duchamp,

Pollock, Warhol, Barney, and others. Thinking with Beuys is something else. It means taking his proposition *Denken ist Form* seriously. It means not to "read" him—not to take him in homeopathically or ingest him like the host. Rather, it means thinking along with Beuys about the form of associations, qualities, properties—three words that you'd be forgiven for considering synonyms. The quarrel between the literary–philosophical mode of thinking and scientific–empirical one might be described as a quarrel between the first and last of these words, associations and properties. *Associations* puts the emphasis on the subjectivized side of existence; *properties* places it on the objectivized side of things.

5

Beuys's work *Queen Bees* (1952) is not about representing the queen bee as a subject per se—he says—but exploring it in bees' wax, in a substance of its own making. In effect, thinking the subject's associations through its properties. For Beuys, the felt qualities of materials are akin to what Bakhtin called chronotopes. According to Bakhtin, the "*chronotope* (literally, 'time-space') applies to the intrinsic connectedness of temporal and spatial relationships[,] artistically expressed."[164] This neologism aims to convey deep spatial-temporal co-dependencies. The two become, in an aesthetic practice, "fused into one carefully thought-out, concrete whole." In this whole, time "thickens, takes on flesh," and space "becomes charged and responsive to the movements of time, plot and history."[165] The metaphors are interesting, in part because Bahktin says his usage—sourced to Einstein's theory of relativity—is *almost, but not entirely,* metaphoric. If Beuysian materials are not things exactly, they are also almost, but not entirely, metaphoric.

4

Are any associations proper to materials? For too long, art (and philosophy) has rummaged through the lost-and-found bin of science for metaphors. Can art be understood as a resource for thinking? Science puts the question—en-frames it, as Heidegger says. More often, it's content to present reproducible *causation*—"teased out from randomized, controlled, prospective studies of adequate sample sizes." On science, Beuys is far from silent:

I experienced a vivid shock in the middle of a lecture on amoebae by a professor who had spent his whole life pondering a couple of fuzzy images of simple cells, somewhere between animal and plant structure. . . . I said "No, that's not my idea of science. I'm still haunted by those images of those little amoebae on that blackboard."[166]

His point is, I suppose, that the chalkboard lesson about amoebae, was that their images were formless for thought in its broader sense, unarresting as an exogenic, nonspecialized truth procedure. Art as critical material practice en-forms thought by giving it props. Science is a clot in the circulatory system (a narrowing of thinking about and explaining the world), art is a stent.

3

Materielle. The basic forms of modernity, returning one last time to Benjamin's *Trauerspiel* book, cannot be abstracted away from the prop bin. Form is placed squarely in the profane thing world, and defined from

FIGURE 49. Noiseless Dustless Eraser. Photograph by author.

an obligation for a shared stock of props. Benjamin employs the parasitical connotation of the word—using the very word parasite, *Parasit*—that makes the thing functionally continuous with other "obligatory ingredients" of the Hamlet machine: poisoned rapiers, dreams, ghostly presences, the horrors of an anticipated end, the witching hour, and, above all, the death's head all tumble out of the prop-cabinet onto the stage. In props, the historical as un-classical finds its proper site of manifest transience, singularity, and ultimately the intense exteriority of bare, theatrical individuality-in-death.

2

How felt felt. Foodies talk about something called mouth-feel: the beaniness of beans, sticky, starchy fullness, a bubbled gumminess that is both a property and an association. Consistency matters; so too, the mastication and swallowing. Felt-felt-touch-feel share an association, a detemporalized narrative, past tense, transitive, expositive. Felt means something to Germans, gray blankets on sledges, it means something else to others, perhaps. Hammers on musical instruments, hats, pianos. How Felt Felts, the mechanical-technical process—is it present-future or future-perfect? Intransitive. Felt makes itself. The pun in English is fortuitous, less so in German—der Filz, filzen. The phoneme makes the difference—felt, felts. How felt felt—that is, how does it feel to feel felt—felt-feel—feeling—but also the question of feeling—how does feeling feel felt? Psychic processing through association, tactile processing through touch. Does any of this inhere in the stuff itself?

I

How felt felt?
 Noiseless. Dustless.

0

Nothing Beside Remains

I wrote [*The Story of Stuff*] to share a journey both personal and material. While exploring where our t-shirts, laptops and books come from, I also share my own journey along the way. I share stories of how I went from being a high school kid interested in forests to an adult fascinated with garbage to realizing that the real solution lay beyond either of those issues in isolation.

—Annie Leonard, *The Story of Stuff*

We're forever telling the story of stuff. It can't speak for itself, so it's narrated, supplied a make-believe shorthand of life stories, biographies, and CVs. The biography of the beer can is a conspicuous example, the narratives of heroic chocolate bars or coffee beans which Bruce Robbins writes about as commodities playing the part of "the impetuous, all conquering character type once attributed to tycoons or discoverers."[1]

In her YouTube presentation, anti-stuff activist, documentarian, and author Annie Leonard stands in front of a diagram.[2] It looks something like an algorithm, one of those Rube Goldberg's machines: a flowchart with a planet, a refinery, a store, a house, and an incinerator. A repeatable sequence of operations, inputs, and outputs, the diagram is not the story. Indeed, the story Leonard shares, in her inimitable awe-shucks way, entails her discovery of this diagram. Curious about where her mysterious iPod came from, she "looked it up" in a "textbook" and there she stumbled on the thing she gestures to, an explanation of the materials economy, as if through stations on the cross, how "stuff moves through a system, from extraction, to production, to distribution, to consumption, to disposal."[3] A sleight of hand is in effect: you can chase down a textbook, but how do you chase down the creation of matter?

When a thing gets talked about, for better or worse, it tends to get couched in one of three kinds of pseudo life stories. First, there's the

FIGURE 50. "The materials economy"—Annie Leonard, *The Story of Stuff*, 2008.

quasi-phenomenological passion play: the thing that lives insofar as it's subject to human attention, born when it's seen, dead when it's lost. A high school kid interested in the forest, in where my iPod came from. Second, a related, more animist, or supernatural, thing-story: it lives an all-too-human life as a human proxy. We feel by means of it. John Ruskin famously denounces this kind of thing-life by naming the pathetic fallacy "a falseness in all our impressions of external things."[4] Memento, sacred artifact, or companionable form, the thing here becomes a human proxy, a temporary vehicle for human affective states, otherwise expressed. In the eighteenth century—the very era, according to Benjamin, when the prop leaves the stage and enters public life—there is an explosion of it-narratives, adventures of pennies, tales of tubs, dolls that rebuke their owners, and so forth. It-narratives, according to Mark Blackwell, are veiled allegories of desires reorienting to an increasingly important commercial society.[5] Sigmund Freud elaborates his concept of the uncanny— another kind of it-narrative—around a doll in E. T. A. Hoffmann's "The Sandman." The automaton is not a neutral presentation of a thing so much as it is an inert hub for a fantastic love story gone awry as well as an allegorical hash-tag about the hazards of bad object relations.

In A. M. Homes's story "A Real Doll," Barbie appears to seduce a pubescent boy. It's clear through more than narrative irony that the plastic

plaything inverts the desires routed through it; the second thing life story is necessarily a tale of an obsessional about his or her stuff. Just as an adult fascinated with garbage, so too the narrator who treks to the toy store to buy his Barbie a present:

> I was at that strange point where I would have done anything for her. . . . I was a wreck. I imagined a million Barbies and having to have them all. I pictured fucking one, discarding it, immediately grabbing a fresh one, doing it, and then throwing it onto a growing pile in the corner of my room. An unending chore. I saw myself becoming a slave to Barbie. I wondered how many Tropical Barbies were made each year. I felt faint.[6]

And, precisely here when scale is invoked, a vortex of a million Barbies, the life stories of things take its third, most wondrous, turn. When the thing assumes the form of the gadget—the widget, the everlasting gob-stopper, Leonard E. Read's pencil—it becomes the protagonist in a fable of production. In the homily, the undertaking of organizing the components necessary (and the agriculture, engineering, industry, transportation, education and finance apparatus behind them) to produce a seemingly ordinary pencil is miraculous, if not divine:

> I, Pencil, am a complex combination of miracles: a tree, zinc, copper, graphite, and so on. But to these miracles which manifest themselves in Nature an even more extraordinary miracle has been added: the configuration of creative human energies—millions of tiny know-hows configurating naturally and spontaneously in response to human necessity and desire and *in the absence of any human master-minding!* Since only God can make a tree, I insist that only God could make me. Man can no more direct these millions of know-hows to bring me into being than he can put molecules together to create a tree.[7]

Unlike thing-life in its more limited form, when the riddle of abstraction is solved by perspectival limits of anthropomorphism, the thing-life of the third kind blows the roof off human scales and sightlines. Telling the story becomes an epic lost-and-found hunt for impossibly inhuman beginnings and endings. "Take any item and trace back to its

true origins, and you will find it takes the whole economy to make any-thing" is the way Leonard describes the genesis of her project, as noth-ing less than a thing-eschatology.

That single sheet of paper before you implies endless forest primeval in Oregon and entails Mount Everest–sized waste heaps in Fresh Kills. Ironically, the would-be miracles of thing-genesis, as related in the san-guine fables of first modernity—harvesting, mining, processing, transport-ing, manufacturing, engineering—become grim mirror-images in the thing-revelations of second modernity. Morose, necrotic mysteries of last rites, imperfect waste disposal, and eons of decay involve the entire anonymous life cycle of things. In this vein, Leonard's story of produc-tion is duly harrowing, if worryingly simplistic: "What happens there is we use energy to mix toxic chemicals in with the natural resources to make toxic contaminated products." Profane from the horizon of first modernity, the destiny of things is posed as a kind of being unto waste. Toxics in, toxics out. This version of thing-life charts a felt way into the life-cycle of materials, the deep, inhuman rhythms unavailable to a sin-gle human frame, and it backslides when it comes to narrative hubris. "How can we run a planet with that level of materials throughput," Leonard asks, as if hanging the story of things in an omniscient frame alone gives us command and control over their destiny. In fact, nothing is certain about stuff, before or after things hurl through our zones of attention. Furthermore, the term equivocates. *Stuff* lies ("are you eating it . . . or is it eating you?"), refusing to discriminate between separate states of matter—unrefined or refined, raw materials or manufactured goods, novelty or waste.[8]

From essayism to (auto)poiesis; conceptual art to prop comedy; thing-play to word-play, *The Way Things Go* eschews narrative. It isn't interested in the *story* of stuff. It is a given that stories about stuff are insufficient as critical practice for the ways things go. Matter being indestructible, first and last things being beyond all horizons, there remains enormous critical and aesthetic necessity for the continued exposition of side effects.

ACKNOWLEDGMENTS

I dedicate this book to Tanja and my children—Zara and Eli—who helped me make everything.

I also owe particular thanks to the Alexander von Humboldt foundation for sponsoring fifteen months of research and writing in Germany and my kind hosts at the Humboldt-Universität in Berlin and the Leibniz Universität in Hannover. Some of this book came from this time. I am also grateful for support from the College of the Arts & Sciences at the University of Louisville and the late Blaine Hudson. Encouragement from Susan Griffin, the chair of the English Department at the University of Louisville, as well as from Tom Byers, the director of the Commonwealth Center for Humanities and Society, was essential to this project. Along the same lines, I wish to thank my excellent colleagues and astute students at the University of Louisville.

I'm thankful to Doug Armato at the University of Minnesota Press for his support of this book, and I appreciate the assistance of Danielle Kasprzak and Erin Warholm-Wohlenhaus.

I discussed the ideas in this book with many people. The material in the book has benefited from presentation in a variety of public settings—both at conferences and invited lectures and in undergraduate and graduate teaching. I'm thankful to the following friends, in particular: Tatjana Soldat-Jaffe, my parents and brothers, Elijah Pritchett, Lynda Mercer, Daniel Conrad, Adam Robinson, Michael Miller, Andrew Rabin, Susan Ryan, Steve Schneider, Glynis Ridley, Alan Golding, Simone Bertacco,

Yin Kit Chan, Nicole Seymour, Matt Hart, Jonathan Eburne, Hester Blum, Daniel Purdy, Jean-Yves Pellegrin, Jonathan Goldman, Sean Latham, Joseph Campana, Seth Morton, Derek Woods, Rodrigo Paula, Laura Richardson, Sara Antonelli, Markus Heide, Rudolph Giltz, Christoph Linder, Siegfried Zielinski, Charles Tung, Benjamin Widiss, Joe Jeon, Michael Coyle, Lucile Dumont, Mark Byron, Alex Pestell, Sean Pryor, Tom McCarthy, Undine Löhfelm, Daniel Nguyen, Patrick Odom, Joe Manning, Dennis Allen, Ron Broglio, Keith Leslie Johnson, Simon Critchley, Brandon Woolf, Jutta Zeisberger, John Gibson, Donal Harris, Janet Lyon, David Ayers, Gunter Süß, Friederike Schulte, Zoe Kusmierz, Katja Kanzler, Frank Usbeck, Matt Brown, Paul Gurner and the St George Bookstore, Martin Klepper, Rainer Emig, Markus Heide, Roger Conover, Steve Watt, Pat O'Donnell, Lois Cucullu, Jessica Burstein, Justus Nieland, Cristina Iuli, Judith Roof, Rob Richardson, Cary Wolfe, Kate Marshall, Julian Murphet, Ed Comentale, and the anonymous readers of University of Minnesota Press.

NOTES

Instruction Manual

1. Reed, "Naming of Parts" 49.

2. Here, I'm thinking of what Peter Sloterdijk calls "dicke Briefe an Freunde": "Letters that are not mailed cease to be missives for possible friends; they turn into archived things. Thus the important books of the past have more and more ceased to be letters to friends, and that they do not lie any longer on the tables and night-stands of their readers has deprived the humanistic movement of its previous power. Less and less often do archivists climb up to the ancient texts in order to reference earlier statements of modern commonplaces. Perhaps it occasionally happens that in such researches in the dead cellars of culture the long-ignored texts begin to glimmer, as if a distant light flickers over them. . . . Everything suggests that archivists have become the successors of the humanists. For the few who still peer around in those archives, the realization is dawning that our lives are the confused answer to questions which were asked in places we have forgotten" (Sloterdijk, "Rules for the Human Zoo," 28).

3. Anything from Scott's oeuvre on continuous loop, from the late *Manhattan Research Inc.* work to *Soothing Sounds for Baby* to the early work collected on *Reckless Nights and Turkish Twilights*. Raymond Scott, *Manhattan Research Inc.*, copyright Basta Audio-Visuals, 2000, compact disc; *Soothing Sounds for Baby, Vols. 1–3*, copyright Basta Audio-Visuals, 1997, compact disc; *Reckless Nights and Turkish Delights*, copyright Sony, 1992, compact disc.

4. Mallarmé, *Oeuvres complètes*, 378.

5. Ibid.

6. See Sontag, *On Photography*, 24.

7. Brockmann, *From Millwrights to Shipwrights*, 277.

8. Martin, *This Is a Book*, xv.

9. Orwell, "Politics and the English Language," 270. Words written in 1945.

10. Calvino, *If on a winter's night a traveler*, 3.

11. Ashbery, *The Mooring of Starting Out*, 8.

12. In his response to Alain Badiou's *Handbook of Inaesthetics*, Rancière points out that modernism (the regime described in the *Politics of Aesthetics* as the "mode of sensible being proper to artistic products") arrives specially defined by its necessity for explication from outside—the modernist thing arrives intertwined, in effect, with the literary-philosophical operator's manuals that provide "orientation[s] for thought" ("Aesthetics, Inasethetics, Anti-Aesthetics," 227–28; and *The Politics of Aesthetics*, 22). "Such is the paradox of the aesthetic regime in the arts. It posits the radical autonomy of art, its independence of any external rule. But it posits it in the same gesture that abolishes the mimetic closure separating the rationale of fictions from that of facts, the sphere of representation from other spheres of existence" (Rancière, *The Future of the Image*, 123). In this regard, Rancière's pure "aesthetic regime" composed of impure stuff (which cracks the mirror to nature, and exits the "Romantic quagmire . . . bogged down in the humus of fossils") resembles Arthur Danto's classic account of the artworld, being less an autonomous preserve unto itself than an institutionalized way of seeing heteronomous ingredients aesthetically that don't get noticed otherwise. "To see something as art," Danto writes, "requires something the eye cannot decry [*sic*, descry] —an atmosphere of artistic theory, a knowledge of the history of art: an artworld" ("The Artworld," 580). Novelty and waste might be imagined as the "objects, machines, and unidentified devices," Rancière mentions, that invade modernity and move in and out of its zones of aesthetic-theoretical attention (*The Politics of Aesthetics*, 19).

13. See, for instance, North, "The Astrolabe." In five minutes, I can have blueprints from the Internet for making my own astrolabe, but in the same five minutes I can also collect all the information an astrolabe can produce. Chaucer makes a point of how much knowledge he must compile and digest from multiple languages to produce his treatise.

14. Whether "Lewis" is really Chaucer's son, his godson, or the son of a patron is a matter of some debate among scholars. There is even speculation that the manual is unfinished because Lewis died. Particularly suggestive for my reading is J. A. W. Bennett's observation that 'Lewis' is "a fiction, to justify the simplicity with which the poet describes 'a certain noubre of conclusiouns apertaing to the same instrument'" (*Chaucer at Oxford*, 33). I thank my friend Andrew Rabin for discussions about these matters.

15. Walton, "To the Reader of This Discourse."

16. Walton, *The Compleat Angler*, 141.

17. *The Ford Manual* (Detroit: Ford Motor Company, 1919), 2.

18. Ibid.

19. Ibid.

20. Brockmann, *From Millwrights to Shipwrights*, 308.

21. The case comes from the second part of Freud, *Beyond the Pleasure Principle*. Neither John Reddick's nor Strachey's translations are entirely satisfying on these

points. For the original, see Sigmund Freud, *Jenseits des Lustprinzips*, Project Guten-
berg EBook, http://www.gutenberg.org/files/28220/28220–h/28220–h.htm.

22. A balloon on a string and yarn-balls before call forth whirligigs. In the flood
of spin-offs (board books, videos, board games) that derive from Margaret Wise
Brown's *Goodnight Moon* (1947), there's a recent DVD adaptation, which includes
animated versions of Clement Hurd's illustrations. *Goodnight Moon . . . and More.*
In a screenshot, the pajama-bedecked hare inventories the property of his bedroom
and an eyeball-like balloon accompanies his survey. Is this red balloon similar to the
one that trails the boy in Albert Lamorisse's short film (1956)? In the DVD version,
the balloon serves as an exegetic, if wordless, pointing device around Hurd's story-
book space: *The moon is full, the lamp has its beam affixed, the fire is lit, but why the
dollhouse? Look, two clocks! Is it 8 o'clock, or is it nearly midnight? Look, what else there
is: a fire, a telephone, a tiger skin rug, paintings in gilt frames, depicting scenes from
other books another rabbit, an outdoorsman in fishing gear!*

23. The plasticity of this word is worth noting, as it's used to designate everyday
objects, antique pieces, interchangeable objects, hazardous materials, personal items,
explosives, antiquated things, and lost property.

24. "Methode dieser Arbeit: literarische Montage. Ich habe nichts zu sagen. Nur
zu zeigen. Ich werde nichts Wertvolles entwenden und mir keine geistvollen For-
mulierungen aneignen. Aber die Lumpen und den Abfall: die will ich nicht inven-
tarisieren sondern sie auf die einzig mögliche Weise zu ihrem Recht kommen lassen:
sie verwenden" (Benjamin, *Gesammelte Schriften* 5:574). "Method of this project:
literary montage. I needn't say anything. Merely show. I shall purloin no valuables,
appropriate no ingenious formulations. But the rags, the refuse—these I will not
inventory but allow, in the only way possible, to come into their own: by making
use of them" (*The Arcades Project*, 460).

25. Rancière, *The Future of the Image*, 14.

26. Lacan, *The Four Fundamental Concepts of Psychoanalysis*, 7.

27. Lacan's Seminar 25, qtd. in Harari, *How James Joyce Made His Name*, 172–73.

28. I owe insights in this paragraph to discussions with Jonathan Eburne about
David L. Martin's *Curious Visions of Modernity*.

29. *The Ford Manual*, 14.

30. The *aktionsart* is, in other words, semelfactive, channeled through a punc-
tuating or initiating event. See Barthes, "From Work to Text," 77.

31. When Adorno in *Negative Dialectics* calls Heidegger to account for his
"sleight-of-hand," in effect, he is making an issue of Heideggerian prestidigitation,
or, *Fingerfertigkeit*—the sense that ready-to-hand all too easily slides into ready-to-
finger—or, considering our technical moment—ready-to-swipe. For Adorno, Hegel
was honest enough to practice the maneuver (of matter becoming concept) in the
open, but "Heidegger, not wanting to be an idealist, shrouds and beclouds the ontol-
ogization of the ontical." Here, one also thinks of Flusser's point about the deluge
of informational non-things seemingly at your fingertips yet "impossible to get a
hold of." The occulted ontologization of the ontical, Adorno notes, takes "utmost

sublimation of the ascetic ideal and makes a fetish of it at the same time. . . . The concept, purified as its [*sic*] rejects its content, functions in secret as the model of a life that is arranged so no measure of mechanical progress—the equivalent of the concept—may ever, under any circumstances, do away with poverty." See Adorno, *Negative Dialectics*, 121; Flusser, "The Non-Thing 1," 86.

32. *Oxford English Dictionary*.

33. See also Steven Brower's comment, "Goldberg's machines don't relate to a personal, individual body so much as a social body"; both Snyder and Brower are quoted in Berry, *Chain Reaction*, 30, 35. See also Biro, *The Dada Cyborg*.

34. Clark, *Being There*, 75.

35. I'm thinking once again of background noise and Serres, who writes that "the ear knows how to loose track" (*Genesis*, 7). In a similar connection, Julian Murphet invokes Mladen Dolar's account of Socrates's daemon: "Against all our fast-frozen preconceptions of the modern as the great epoch of innovation, creation and revelation, perhaps modernism should be constructively reformulated as the insistent whispering of a certain Socratic voice which 'whenever it speaks turns me away from something I am about to do, but never encourages me to do anything" (Murphet, *Multimedia Modernism*, 80). See also Dolar, *A Voice and Nothing More*, 83.

36. Jovi Schnell discusses the relation of her own work to Goldberg's drawings in Berry, *Chain Reaction*, 31.

37. Qtd. in ibid., 24–25 (*Physical Plant*, 2001, acrylic, thread, and collage on wall, appears on p. 30).

38. Ibid., 28. On this point, see Steven Brower's comments in particular.

39. Luhmann, *Observations on Modernity*, 3.

40. Contrast Eric Hobsbawm's short twentieth century, in *Age of Extremes: The Short Twentieth Century 1914–1991* (London: Abacus, 1994), with the long centuries expounded in Gerald Raunig's *Art and Revolution* (Cambridge, Mass.: MIT, 2007) which stretch from the Paris Commune of 1871 to the antiglobalization protests in Genoa in 2001 and Giovanni Arrighi's *The Long Twentieth Century* (New York: Verso, 2010), which takes on a seven-hundred-year spree.

41. This formulation is coined by Brian Eno and has been adopted by the Long Now Foundation, "established in 01996 to creatively foster long-term thinking and responsibility in the framework of the next 10,000 years," is building a ten-thousand year clock, "designed to run for ten millennia with minimal maintenance and interruption" as a *denkmal* to this notion (The Long Now Foundation, *The 10,000 Year Clock*, http://longnow.org/clock).

42. I'm thinking, with this playful repurposing of Rousseau, of Chris Marker's *La jetée*, which perfectly captures the critical orientation of second modernity. Incidentally, Marker's nom de plume was said to have been taken from a Magic Marker pen.

43. This critical account extrapolates freely from Ulrich Beck's account of second modernity. The case for a second modernism, a reflexive turn in cultural value, depends on two observations about novelty and waste; contaminated relations

detected in the everyday experience of things implicate experiences of the past and present, and relations of the bodies' insides and outsides (Beck, *Risk Society*, 169).

44. Qtd. in Murphet, *Multimedia Modernism*. 12.

45. McCarthy, *C*. 63.

46. Driscoll, *Modernist Cultural Studies*.

47. Hatherley, *Militant Modernism*, 13.

48. See Julian Murphet, "Modernism Now and Then," May 26, 2011, http://www.youtube.com/watch?v=T2IxDpQ3vuE. See also Tom McCarthy's obituary for Kittler, "Kittler and the Sirens," *London Review of Books*, November 9, 2011, http://www.lrb.co.uk/blog/2011/11/09/tom-mccarthy/kittler-and-the-sirens.

49. Murphet, *Multimedia Modernism*, 14.

50. Wittgenstein, *Remarks on the Philosophy of Psychology*, 16e, §75. Wittgenstein references Jastrow as his source for the figure, which I have included here: Jastrow, "The Mind's Eye," 312.

51. See Rancière, "Aesthetics, Inasethetics, Anti-Aesthetics." 220–21: "[L]iterature is the name under which disorder first affected the art of writing before going on to spread its confusions in the realms of the so-called plastics arts and the so-called theatrical arts."

52. I'm not only thinking of the proliferation of treatments of specific things such as Mark Kurlansky's *Salt: A History*, Tim Morton's *The Poetics of Spice*, Michael Pollan's *The Botany of Desire*, etc., but also in critical works such as Bill Brown's *A Sense of Things*, Jane Bennett's *Vibrant Matter*, and Robert Chodat's *Worldly Acts and Sentient Things*, and even savvy contemporary theorists of technology such as Friedrich Kittler or Bernard Stiegler.

53. See Weber, *Mass Mediauras*, 87n6.

54. Qtd. in Blanchot, *The Writing of the Disaster*, 7. The exploding book is no dream: "Inside Adams' factory, a girl worker places explosions in exploding books. Adams buys thousands of unsold books from publishers to fill a demand that seemingly goes on forever" (Soule, "Fun's Henry Ford," 125). Concerning exploding books and other novelties manufactured by the S. S. Adams Company, see #57–#54.

55. Marx makes this point well before Heidegger: "It is by their imperfections that the means of production in any process bring to our attention their character of being the products of past labour. A knife which fails to cut, a piece of thread which keeps on snapping, forcibly remind us of Mr A, the cutler, or Mr B, the spinner. In a successful product, the role played by past labour in mediating its useful properties has been extinguished" (Marx, *Selected Writings*, 279).

56. Raine, *A Martian Sends a Postcard Home*, 2.

57. Hulse, "An Occasion for Shrieking?," 63.

58. See Burroughs, *Conversations with William S. Burroughs*, 200.

59. Shklovsky, "Art as Device."

60. Raine nevertheless endorses Shklovsky's words that "art exists in order . . . feel objects, to make the stone stony": see Carr, "An Interview with Craig Raine," *New Directions* 54(1990): 39.

61. Ibid.

62. Adapted from this nifty assignment: Ewa Chruściel, 301 Intermediate Creative Writing: Poetry, Colby-Sawyer College, http://www.echrusciel.net/documents/Ewa_Chrusciel_English_301_Intermidiate_Creative_Writing_Poetry.pdf.

63. Donaghy and Muldoon, "A Conversation with Paul Muldoon," 83.

64. Ibid.

65. Pound, "In a Station of the Metro," 111.

66. "Vorticism" (BK12) appeared in *Fortnightly Review*, n.s., 96 (September 1914): 461–71. See http://themargins.net/anth/1910–1919/poundmetro.html.

67. Serres, *The Parasite*, 3. Incidentally, Rancière likens Badiouian inaesthetics to a UFO invasion handbook (Rancière, "Aesthetics, Inasethetics, Anti-Aesthetics," 218).

68. Even though in an interview he endorses the idea that "art exists in order . . . feel objects, to make the stone stony," Raine claims to have "not heard of Shklovsky."

69. Macintyre, *Operation Mincemeat*.

70. On the skeumorph, see Hayles, *How We Became Posthuman*, 13–17. Nothing seems to elicit the tedious fury of the techno-Benthamite apostles of creative destruction more than the iconography of dead media. See, for instance, Farhad Manjoo, "Delete the Save Button," *Slate*, July 18, 2012. Here, we see the elevation of childlike curiosity about things into a disposition of relentless ignorance about reference to past stuff. The argument that new adopters of tech have no memories for things made obsolete by tech (such as safes, scissors, radio buttons, reel-to-reel tape and film, folders and file cabinets, phone handsets, magnifying glasses and binoculars, envelopes, wrenches, screwdrivers and gears, old-style microphones, envelopes, cameras, TVs with antennas, carbon copies or blueprints) obscures a certain reparative skeuomorphic aura that lags in all these things. One commentator—complaining about floppy disks ("an [i]con that means 'save' for a whole generation of people who have never seen one") as well as the profligate use of wrenches and gears to indicate setup and settings applications ("Want to indicate Settings or Setup to a twenty something? Show them a tool they've never used in their lives") laments the relative lack of cloud iconography—oblivious to the problem that this "generation" will likely have never seen the outdoors. See Scott Hanselman, "The Floppy Disk Means Save" May 8, 2012, http://www.hanselman.com/blog.

71. Johnson, "Introduction to *Aren't You Rather Young*," 151.

The Way Things Go

1. Kurzweil, *The Singularity Is Near*.

2. Wells, *The Sleeper Awakes*, 56.

3. Ibid.

4. Allen, dir., *Sleeper*.

5. That our times are prepossessed by melancholy about the book as the last, lost toy is reflected in the predominance of narratives that are written from a speculative frame in which this disappearance is already accomplished. See, for instance, "When

Hard Books Disappear," in which books, on the model of seeds in a seed bank, are warehoused for posterity.

6. See Fitzpatrick, *Anxiety of Obsolescence*.

7. Benjamin, "Unpacking My Library," 60.

8. Duffy, *The Speed Handbook*.

9. Chesterton, *On Lying in Bed and Other Essays*, 477.

10. Lewis, *BLAST*, 8. On the conjunction of Vorticism and Dada, see Caws, *Manifesto*.

11. Wilde, "Letter to Robert Ross," 1187. Thanks to Rob Richardson.

12. On the connection between Mr. Toad and Mr. Wilde, see Knoeplmacher, "Oscar Wilde at Toad Hall. "

13. Duffy, *The Speed Handbook*, 42.

14. "Ich glaube an das Pferd. Das Automobil ist eine vorübergehende Erscheinung," Kaiser Wilhelm II, as reported on an exhibit label in Mercedes-Benz Museum, Stuttgart, Germany.

15. Armleder's insight is that the place where the commodity and artwork rub shoulders is the back of the cargo van, during a pit stop at the museum on the way from the dumpster. The museum text beside the vehicle reads as follows: *"Don't do it!* combines the most famous ready-mades, from Duchamp's *Urinoir* (1917) via Warhol's soap powder boxes and Beuys' felt rolls (around 1960) through to [Rirkrit] Tiravanija's teabag (1998)—but all of them as new, fresh from the market acquisitions. *Don't do it!* is a double farewell to the concept of the original in art: in the course of time, the ready-made, which was to destroy the aural of the artistic original and the associated ideals and utopias, has risen to the status of an icon itself. Armleder's sculpture tears down the ready made from its pedestal for a second time to move the essential and the truly 'original' artistic approach into focus."

16. Duffy, *The Speed Handbook*. 41. See Serres, *Hermes*.

17. At a second glace, "modernism" turns out less a period or a style (that stubborn false dichotomy) than a heuristic for a new, ethically ambivalent system of cultural value with a trailing self-reflexive turn toward cultural orientation, management, and administration. Given that we can't tell, as observers subject to modernity's event horizon, if this situation is one of continuation or repetition, the cultural scenes are freighted not with indeterminacy but with risk, ambivalence, and undecidability.

18. Olson, *The Maximus Poems*, 220.

19. Clarsen, *Eat My Dust*.

20. Ibid., 10.

21. Penzel, *Objekte im Rückspiegel*, 10 (unless otherwise noted, all translations are mine).

22. Here, a multilinguistic distinction between movable properties and immovable property (Möbel, Immobilien) is apropos, and a paradox of second modernity noted by Flusser, namely that real estate ("Poland") may move more than the furniture in one's dwelling.

23. Penzel, *Objekte im Rückspiegel*, 11.

24. With everything manufactured elsewhere, the "baker" is reduced to stocking the self-serve cases, tidying up the floor, and running the cash register. See, for example, Back-Factory's website at http://www.back-factory.de/.

25. Penzel, *Objekte im Rückspiegel*, 11–12. For Read's "I, Pencil," see http://www .econlib.org/library/Essays/rdPncl1.html.

26. On collisions between elastic bodies, see Lovett, Moulding, and Anktell-Jones, "Collisions between Elastic Bodies."

27. Fischli and Weiss, *Der Lauf der Dinge*.

28. Kael, *The Citizen Kane Book*, 71.

29. Concerning obsessive objects and narrative perpetual motion machines, the gimmick might be fruitfully compared to Alfred Hitchcock's McGuffin or David Lynch's Eye of the Duck. Both attempt to provide a critical vernacular for following the ways things go and for designating proxies for trailing audience structures. To explain the McGuffin—the lighter in *Strangers on a Train*, for instance—Hitchcock relates an almost Pinterian scenario. Two strangers meet on a train. One asks the other, what's in that package of yours up in the rack? Oh, not much, only a McGuffin. What's a McGuffin? An apparatus for trapping lions in Scotland. There are no lions in Scotland. Precisely. See Sidney Gottlieb, *Framing Hitchcock* (Detroit: Wayne State University Press, 2000) 48. Here, the McGuffin designates both a threatening genre prop (bearing the legend, *look no further*) and the epitome of misdirection. Its fate is pronounced not simply along the interface of heroes and villains, working out their struggles, but, more importantly, as a hub for mobilizing audience interest. Lynch's Eye of the Duck takes a different tack: "If you study a duck, you'll see certain things: the bill is a certain texture and a certain length; the head is a certain shape; the texture of the bill is very smooth and it has quite precise detail and reminds you somewhat of the legs (the legs are a little more rubbery). The body is big, softer, and the texture isn't so detailed. The key to the whole duck is the eye and where it is placed. It's like a little jewel. It's so perfectly placed to show off a jewel—right in the middle of the head, next to this S-curve with the bill sitting out in front, but with enough distance so that the eye is very well secluded and set out. When you're working on a film, a lot of times you can get the bill and the legs and the body and everything, but this eye of the duck is a certain scene, this jewel, that if it's there, it's absolutely beautiful. It's just fantastic" ("The Eye of the Duck," Lost on Mulholland Dr., http://www.mulholland-drive.net/studies/duck.htm). Lynch's mechanical duck is, in effect, an imaginary apparatus for trapping the audience with Bob in Laura Palmer's bedroom. With the duck as *Gesamtkunstwerk*, its eye is akin to a jewel bearing in a Swiss clock. As such, it is found not shown, and, like Barthes's punctum, it's not so much a message from auteur to audience as it presents an auspicious blockage in the audience's sight lines. One more cognate here might be Victor Pelevin's Black Briefcase: "The main character of much of modern cinema and pop-literature—all of pop-culture—is a black briefcase full of money. We mostly follow its fate, and the fates of the other characters depend on it" (Ostap

Karmodi, "'A Frightening Time in America': An Interview with David Foster Wallace," NYR Blog, June 13, 2011, http://www.nybooks.com/blogs/nyrblog/2011/jun/13/david-foster-wallace-russia-interview/).

30. Richter, "Vormittagsspuk" (1928).

31. Qtd. in Kuenzli, *Dada and Surrealist Film*, 6.

32. Wollen, "Magritte and the Bowler Hat." See also Robinson, *The Man in the Bowler Hat*. Jacques Rancière's remarks on Charles Bovary's hat and "its incapacity for an adequate transfer of signifcations" are also apposite here (Rancière, *The Future of the Image*. 13–14).

33. Le Corbusier builds his ideal museum around the bowler hat: he wrote in 1925 that he wanted a museum of "a plain jacket, a bowler hat, a well-made shoe. An electric light bulb with bayonet fixing; a radiator; . . . our everyday drinking glass and bottles of various shapes" (qtd. in Wollen, "Magritte and the Bowler Hat," 137.

34. Schrödinger: "It is typical of these cases that an indeterminacy originally restricted to the atomic domain becomes transformed into macroscopic indeterminacy, which can then be resolved by direct observation. That prevents us from so naively accepting as valid a "blurred model" for representing reality. In itself it would not embody anything unclear or contradictory. There is a difference between a shaky or out-of-focus photograph and a snapshot of clouds and fog banks"; see Trimmer, "The Present Situation in Quantum Mechanics," 328.

35. Honda, "The Cog," http://www.youtube.com/watch?v=_ve4M4UsJQo.

36. Fischli and Weiss, *The Way Things Go*.

37. Le Corbusier, *The Decorative Art of Today*, 22.

38. Serres, *The Parasite*, 160.

39. Ibid.

40. Ibid., 160–61.

41. Flusser, "Non-Thing 2," 87–88. Something like this: Industrial Shredder, JWC Environmental, http://thedailywh.at/2011/06/12/industrial-shredder-of-the-day.

42. Flusser, "Non-Thing 2," 93.

43. Weber, *Theatricality as Medium*. Here, I also have in mind the expositive dimensions of conceptual mise-en-scène discussed by Rancière. See Rancière, *The Future of the Image*, esp. 43–51; as well as his "Aesthetics, Inasethetics, Anti-Aesthetics," 228–29.

44. Benjamin, *The Origin of German Tragic Drama*, 176–77; see also 133–35.

45. Genette, *Mimologics*.

46. Benjamin, *The Origin of German Tragic Drama*, 16ff.

47. Genette, *Mimologics*, 6.

48. Ibid., 26–27.

49. Benjamin, *The Origin of German Tragic Drama*, 45.

50. Ibid., 5–6, 25.

51. Harris and Korda, *Staged Properties in Early Modern English Drama*, 1.

52. Also cited in the OED: Jerome, *On the Stage*, 32.

53. Benjamin, *The Origin of German Tragic Drama*, 312. Pages refer to the German ed. "In the developed form of the tragedy of fate there is no getting away from the stage-property" (134). "Vom Requist ist fuer die ausgebildete Form des Schicksalsdrama nicht zu abstrahieren" (312).

54. Ibid., 313–14.

55. The etymopoetic links to *Werkzeug* (tool, instrument) and *Spielzeug* (toy) are also noteworthy.

56. Benjamin, *The Origin of German Tragic Drama*. 177.

57. Ibid., 342–43, 166.

58. Ibid., 158.

59. Weber, *Theatricality as Medium*.

60. Ibid., 6.

61. Ibid.

62. Ball, "Chris Ware's Failures," 50.

63. Sartre, "A Fundamental Idea of Husserl's Phenomenology," 383.

64. Brown, "Thing Theory."

65. Brown, *A Sense of Things*, 7.

66. See n.17 above. Ulrich Beck, *Risk Society* (London: Sage, 1992).

67. Allen, "The Discovery and Use of the Fake Ink Blot," 99.

68. Self, *Junk Mail*, 140.

69. Allen, "The Discovery and Use of the Fake Ink Blot," 101.

70. Italics added. Cummings, *100 Selected Poems*, 89.

71. Newgarden, *Cheap Laffs*, 104. See also Demarias, *Life of the Party*.

72. See, for instance: U.S. Department of Health and Human Services, *Report of Carcinogens* (2011), http://ntp.niehs.nih.gov/ntp/roc/twelfth/roc12.pdf, and, similarly, the European Union's ban, http://eur-lex.europa.eu/LexUriServ/LexUriServ.do?uri=CELEX:31983L0264:EN:HTML.

73. Brown, *A Sense of Things*.

74. Zolotow, *It Takes All Kinds*, 122ff.

75. Baudelaire, "Selected Writings on Art and Literature," 398.

76. Baudelaire, *Paris Spleen*, 12–15.

77. Ibid., 14, 13.

78. Brown, *A Sense of Things*, 7.

79. W. Williams, *Kora in Hell*, 25–26.

80. MoMA Gallery Text, http://www.moma.org/collection/object.php?object_id=81212.

81. Eliot, "Tradition and the Individual Talent," 38.

82. Ibid.

83. Brown, "Thing Theory," 1.

84. Sheppard, *The Whole Fun Catalogue of 1929* (New York: Chelsea House, 1979), v.

85. Mariani, *The Broken Tower*, 24. Also: "Clarence A. Crane," Ohio History Central, July 28, 2006, http://www.ohiohistorycentral.org/entry.php?rec=2634.

86. Crane, *The Complete Poems*, 34.

87. Hart Crane, "Hart Crane and Harriet Monroe Debate the 'Logic' of Poetry," Lit Hum, June 30, 2011, http://www.lit-hum.org/2011_06_01_archive.html.

88. Eliot, *Collected Poems, 1909–1962*, 63.

89. Moretti, *Graphs, Maps and Trees*, 46.

90. Brown, *A Sense of Things*, 7.

91. Heidegger, "The Thing."

92. Brown, *A Sense of Things*, 171.

93. Marx and Engels, *The Marx-Engels Reader*, 319–20.

94. Chodat, *Worldly Acts and Sentient Things*, vii.

95. In *The Parasite*, Serres likens the quasi thing to "an explosive novelty," or the joker, which alters the pattern of play, by altering direction: "That joker is a logical object that is both indispensable and fascinating. Placed in the middle or at the end of a series, a series that has a law of order, it permits it to bifurcate, to take another appearance, another direction, a new order. The only describable difference between a method and bricolage is the joker. The principle of bricolage is to make something by means of something else, a mast with a matchstick, a chicken wing with tissue meant for the thigh, and so forth. Just as the most general model of method is game, the good model for what is deceptively called bricolage is the joker" (Serres, *The Parasite*, 161). Flusser's non-thing, by contrast, is anti-novelty itself, the gadget heralding the dominion of the "vicious cycle" of second culture ("nature to culture to waste"). Non-things "flood our environment from all directions, displacing things," he writes, yielding unscalable mountains of junk: "This throw-away material, all those lighters, razors, pens, plastic bottles, are not true things; one cannot hold on to them. And just as we get better and better at learning how to feed information into machines, all things will be transformed into the same kind of junk, even houses and pictures. All things will lose their value, and all values will be transformed into information." Ephemeral and eternal, the non-thing is "impossible to get hold of," yet it's at the disposal of the information zombies, remote-button pressers, trigger pullers, fuse lighters, and fingertip swipers, those who set in motion preprogrammed chain reactions. Modern things—or better, the jokers and the non-things—come with conditions. Making sense of them means making sense of these conditions; above all, the appearance of new things, novelties, and the inability to differentiate anything from anything else, waste. See Flusser, "The Non-Thing 1," and "The Non-Thing 2," 85–94.

96. Oliver Wendell Holmes, *Abrams vs. United States*, 1919.

97. Loy, *The Lost Lunar Baedeker*, 79–80.

98. See "The Case of Constantin Brancusi vs. the United States of America: An Extract," *Art Newspaper* no. 63 (October 1996), available at http://bellevuecollege.edu/artshum/materials/art/Tanzi/Summer04/203T/BrancusiCourtCase.htm.

99. As in, for instance, "[a]s Brancusi shaped in brass, so Mina Loy in the poems on art shapes and polishes language to achieve exquisite verbal sculptures" (Kouidis, "Rediscovering Our Sources," 94.

100. Danto, *The Madonna of the Future*, 178. See also Camfield, "Marcel Duchamp's Fountain," 152.

101. Danto, *The Madonna of the Future*, 179.

102. Loy, *The Lost Lunar Baedeker*, 213.

103. Masteller, "Using Brancusi," 60.

104. Andreotti, "Golden Bird," 142.

105. Pound, "Brancusi," 443.

106. Foucault, *This Is Not a Pipe*, 26.

107. Torczyner, *Magritte*, 71.

108. Foucault, *This Is Not a Pipe*, 27.

109. CleanRiver Recycling Solutions, Mini Bin, Frequently Asked Questions, http://www.cleanriver.com/mini-bin-faqs.

110. Single Stream Recycling at the University of Louisville, https://louisville.edu/kppc/intranet/references/recycing-info.pdf.

111. Beavan, "Our Trip to the Farm." In 2009, Beavan published a book about his "experiment," and was the subject of a documentary by Laura Gabbert and Justin Schein.

112. Beck, *Risk Society*. Modernism's investments in a variety of negatives come to mind: defamiliarization, alienation, ostranie, negative aesthetics, untimeliness, unease, obscenity, mischief, snobbery, outrage and other rude assignments. As Rebecca Walkowitz and Douglas Mao have noted, modernism may be a name for the cultural dynamics of one such side effect: "No other name for a field of cultural production evokes the constellation of negativity, risk of aesthetic failure, and bad behavior than modernism does. But a profound peril lurked in this involvement with badness: it left modernism's program vulnerable to incoherence once its work achieved wide acceptance as good" (*Bad Modernisms*, 4).

113. Beck, *Risk Society*, 19–20.

114. Ibid., 51.

115. Beck, *Cosmopolitan Vision*, 7.

116. Beck, *Risk Society*, 33–34.

117. Palahniuk, *Fight Club*, 72.

118. Powers, *Gain*, 21.

119. Ibid., 34–35.

120. Ibid., 33.

121. Ibid., 211.

122. Ibid., 35.

123. Ibid., 102.

124. Ibid., 154.

125. Ibid., 155.

126. Ibid., 158–59.

127. Ibid., 321.

128. Ibid., 284.

129. Ibid., 304.

130. Beck, *Cosmopolitan Vision*, 46.
131. Beck, *Risk Society*, 162.
132. Ibid., 22.
133. Ibid., 122.
134. Ibid., 128.
135. Ibid., 128, 88.
136. Ibid., 90.
137. Ibid., 129.
138. Bauman, *Liquid Modernity*.
139. Beck, *Risk Society*, 94.
140. Ibid., 137.
141. Beavan, "Day One."
142. Williams, "Culture Is Ordinary," 7.
143. Ibid., 6.
144. Ibid., 8.
145. Ibid., 10–11.
146. Dunlop, "The Third Way."
147. Ibid.
148. Beavan, "Time to Make a Splash."
149. Beavan, "Kant's Views on No Impact Living."
150. Beck, *Risk Society*, 31. Here especially, second modernity's temporality comes to the fore.
151. The point being its status as a biographical aesthetic. See Lash, *Another Modernity*, 3.
152. Beck, *Risk Society*, 23.
153. Beavan, "The Year-Long Plan."
154. Beuys, *Joseph Beuys*, 23.
155. The action took place on November 26, 1965 at the Galerie Schmela in Düsseldorf, Germany. There are several clips of the performance on the Internet with Beuys clomping around, the hare's ears in his mouth, and bemused gawkers outside the gallery. Even more notable are several well-known (and easy to find) photographs of the performance. One by Walter Vogel makes Beuys's face seem zombie-like, its expression inscrutable; a gold-leafed crypt-keeper cradling quarry with the "pictures" on the wall behind them. Another, taken by Ute Klophaus, shows the artist seated on a bench, felt roll nearby, and a small ski tied to his boot. Here, he's pursing his lips, holding the hare tenderly, and lifting his index finger pedagogically. Also instructive is Klophaus's photograph from the aftermath of the action. Here, Beuys is missing and only the props remain—for all their careful arrangement, the limp, lifeless rabbit on a bench, the audio equipment, the trademark felt roll, the relics all appear used up: the still-life after the hunt, as it were.
156. Lacan, *The Four Fundamental Concepts*.
157. De Lucrezia and De Domizio, *The Felt Hat*, 192.
158. Ibid., 201–2.

159. Ibid., 202. Beuys's 1969 installation *The Pack* (or *Das Rudel*) is set up with two dozen sleds, each strapped with its own survival kit, spilling out of the back of a run-down Volkswagen bus. He describes this "invasion by the pack" as "an emergency object": "In a state of emergency the Volkswagen bus is of limited usefulness, and more direct and primitive means must be taken to ensure survival" (qtd. in Poggi, "Mass, Pack, and Mob," 192).

160. De Lucrezia and De Domizio, *The Felt Hat*, 201–2.

161. This material comes from the textile exhibit at Deutsches Technikmuseum Berlin as well as Harper, *Introduction to Textile Chemistry*, 7–11.

162. Hughes, "The Noise of Beuys," 89.

163. Danto, "Style and Salvation in the Art of Beuys," xiii.

164. Bakhtin, *The Dialogic Imagination*, 84.

165. Ibid.

166. Ibid., 22.

Nothing Beside Remains

1. Robbins, "Commodity Histories," 456.

2. It's telling that the Author comes last in the sequence.

3. Leonard, *The Story of Stuff*.

4. Ruskin, "Of the Pathetic Fallacy," 65.

5. See Blackwell, "The It-Narrative in Eighteenth-Century England," 2–3, and his introduction to *The Secret Life of Things*.

6. Homes, *The Safety of Objects*, 160.

7. Read, "I, Pencil."

8. "When I say 'Stuff,'" Leonard writes, "I mean manufactured or mass-produced goods, including packaging, iPods, clothes, shoes, cars, toasters, marshmallow shooters. . . . Stuff we buy, maintain, lose, break, replace, stress about, and with which we confuse our personal worth. Stuff as I define it here is also known as 'crap.' You could substitute the word 'goods; every time you see the word 'Stuff,' but since goods are so often anything but good—i.e., excessively packaged, toxics-laden, unnecessary, and destructive of the planet—I don't like to use that term" (*The Story of Stuff*).

BIBLIOGRAPHY

Adams, S. S. Joke Buzzer. U.S. Patent 1,845,735. Filed November 12, 1931. Issued February 16, 1932.

Adorno, Theodor. *Negative Dialectics*. New York: Continuum, 1981.

Allen, Woody. "The Discovery and Use of the Fake Ink Blot." In *The Insanity Defense: The Complete Prose*, 99–102. New York: Random House, 2007.

———, dir. *Hannah and Her Sisters*. Orion, 1986.

———, dir. *Sleeper*. United Artists, 1973.

Andreotti, Margherita. "'Golden Bird': A New Species of Modern Sculpture." *Art Institute of Chicago Museum Studies* 19, no. 2 (1993): 134–203.

Ashbery, John. *The Mooring of Starting Out: The First Five Books of Poetry*. Hopewell, N.J.: Ecco Press, 1997.

Bakhtin, M. M. *The Dialogic Imagination: Four Essays*. Translated by Caryl Emerson and Michael Holquist. Austin: University of Texas Press, 1981.

Ball, David M. "Chris Ware's Failures." In *The Comics of Chris Ware: Drawing Is a Way of Thinking*, edited by David M. Ball and Martha B. Kuhlman, 45–61. Oxford: University of Mississippi Press, 2010.

Barthes, Roland. "From Work to Text." In *Textual Strategies: Perspectives in Post-Structuralist Criticism*, edited by Josué V. Harari, 73–81. Ithaca: Cornell University Press, 1979.

Baudelaire, Charles. *Paris Spleen*. New York: New Directions, 1970.

———. "Selected Writings on Art and Literature." In *The Painter of Modern Life*, 394–422. New York: Penguin, 1995.

Bauman, Zygmunt. *Liquid Modernity*. Cambridge: Polity, 2000.

Beavan, Colin. "Day One and the Whole Thing Is a Big Mistake." No Impact Man, February 22, 2007, noimpactman.typepad.com/blog/2007/02/day_one_and_the.html.

———. "Kant's Views on No Impact Living." No Impact Man, June 13, 2007, http://noimpactman.typepad.com/blog/2007/06/kants_views_on_.html.

————. *No Impact Man: The Adventures of a Guilty Liberal Who Attempts to Save the Planet and the Discoveries He Makes about Himself and Our Way of Life in the Process*. New York: Farrar, Straus and Giroux, 2009.

————. "Our Trip to the Farm." No Impact Man, May 30, 2007, http://noimpact man.typepad.com/blog/2007/05/our_trip_to_the.html.

————. "Time to Make a Splash (With Your Help)." No Impact Man, September 18, 2007, http://noimpactman.typepad.com/blog/2007/09/time-to-make-a-.html.

————. "The Year-Long Plan." No Impact Man, February 20, 2007, http://noim pactman.typepad.com/blog/2007/02/the_no_impact_p.html.

Beck, Ulrich. *Cosmopolitan Vision*. Cambridge: Polity, 2006.

————. *Risk Society*. London: Sage, 1992.

Benjamin, Walter. *The Arcades Project*. Cambridge, Mass.: Harvard University Press, 1999.

————. *Gesammelte Schriften*. Vol. 5. Frankfurt a.M.: Suhrkamp, 1982.

————. One-Way Street, and Other Writings. New York: Penguin, 2009.

————. *The Origin of German Tragic Drama*. London: Verso, 2009.

————. "Unpacking My Library." In *Illuminations*, 59–68. New York: Schocken, 1977.

Bennett, J. A. W. *Chaucer at Oxford and at Cambridge*. Toronto: University of Toronto Press, 1974.

Berry, Ian. *Chain Reaction: Rube Goldberg and Contemporary Art*. Saratoga Springs, N.Y.: Tang Museum, Skidmore College, 2001.

Beuys, Joseph. *Joseph Beuys*. New York: Dia Art Foundation, 1988.

Biro, Matthew. *The Dada Cyborg*. Minneapolis: University of Minnesota Press, 2009.

Blackwell, Mark. Introduction to *The Secret Life of Things: Animals, Objects, and It-Narratives in Eighteenth-Century England,* edited by Mark Blackwell, 9–18. Lewisburg: Bucknell University Press, 2007.

————. "The It-Narrative in Eighteenth-Century England: Animals and Objects in Circulation." *Literature Compass* 1 (2004): 1–5.

Blanchot, Maurice. *The Writing of the Disaster*. Lincoln: University of Nebraska Press, 1995.

Brockmann, R. J. *From Millwrights to Shipwrights to the Twenty-First Century: Explorations in a History of Technical Communication in the United States*. Cresskill, N.J.: Hampton, 1998.

Brown, Bill. *A Sense of Things: The Object Matter of American Literature*. Chicago: University of Chicago Press, 2003.

————. "Thing Theory." *Critical Inquiry* 28, no. 1 (2001): 1–22.

Brown, Margaret Wise, and Clement Hurd. *Goodnight Moon*. New York: Harper and Row, 1947.

Burroughs, William S. *Conversations with William S. Burroughs*. Edited by Allen Hibbard. Oxford: University Press of Mississippi, 1999.

Calvino, Italo. *If on a winter's night a traveler*. New York: Harcourt Brace Jovanovich, 1982.

Camfield, William. "Marcel Duchamp's Fountain: Aesthetic Object, Icon, or Anti-Art?" In *The Definitively Unfinished Marcel Duchamp*, edited by Thierry de Duve, 133–78. Cambridge, Mass.: MIT Press, 1991.

Carr, Mary. "An Interview with Craig Raine." *New Directions* 54 (1990): 34–41.

Caws, Mary Ann. *Manifesto: A Century of Isms*. Lincoln: University of Nebraska Press, 2001.

Chesterton, G. K. *On Lying in Bed and Other Essays*. Calgary: Bayeux Arts, 2000.

Chodat, Robert. *Worldy Acts and Sentient Things*. Ithaca: Cornell University Press, 2008.

Clark, Andy. *Being There*. Cambridge, Mass.: MIT Press, 1997.

Clarsen, Georgine. *Eat My Dust*. Baltimore: Johns Hopkins University Press, 2008.

Le Corbusier. *The Decorative Art of Today*. Cambridge: MIT Press, 1987.

Crane, Hart. *The Complete Poems and Selected Letters and Prose of Hart Crane*. New York: Anchor, 1966.

Crichton, Charles, dir. *The Lavender Hill Mob*. 1951.

Cummings, E. E. *100 Selected Poems*. New York: Grove/Atlantic, 1954.

Dadaphone 7 (March 1920).

Danto, Arthur. "The Artworld." *Journal of Philosophy* 61, no. 19 (1964): 571–84.

———. *The Madonna of the Future: Essays in a Pluralistic Art World*. New York: Farrar, Straus and Giroux, 2000.

———. "Style and Salvation in the Art of Beuys." In *Joseph Beuys: The Reader*, edited by Claudia Mesch and Viola Michely, xiii–xviii. New York: I. B. Tauris, 2007.

De Lucrezia, Domizio, and Lucrezia De Domizio. *The Felt Hat: Joseph Beuys, a Life Told*. Milan: Charta, 1997.

Demarias, Kirk. *Life of the Party: A Visual History of the S.S. Adams Company*. Neptune, N.J.: S. S. Adams, 2006.

Dolar, Mladen. *A Voice and Nothing More*. Cambridge, Mass.: MIT Press, 2006.

Donaghy, Michael, and Paul Muldoon. "A Conversation with Paul Muldoon." *Chicago Review* 35, no. 1 (1985): 76–85.

Driscoll, Catherine. *Modernist Cultural Studies*. Gainesville: University Press of Florida, 2010.

Duffy, Enda. *The Speed Handbook*. Durham: Duke University Press, 2009.

Dunlop, Tim. "The Third Way: Our Moral Duty to 'Free Markets,'" May 7, 2002, http://webdiaryarchive.com/2002/05/07/the-third-way-window-dressing-for-capitulation.

Eliot, T. S. *Collected Poems, 1909–1962*. New York: Harcourt Brace Jovanovich, 1991.

———. "Tradition and the Individual Talent." In *Selected Prose of T. S. Eliot*. 37–44. New York: Farrar, Straus and Giroux, 1975.

Fischli, Peter, and David Weiss, dirs. *Der Lauf der Dinge*. DVD, Quantum Leap. 1987.

———. *The Way Things Go*. Icarus Films website, http://icarusfilms.com/cat97/t-z/the_way_.html.

Fitzpatrick, Kathleen. *Anxiety of Obsolescence: The American Novel in the Age of Television*. Nashville: Vanderbilt University Press, 2006.

Flusser, Vilém. "Non-Thing 1." In *The Shape of Things*, 85–89. London: Reaktion, 1999.

———. "Non-Thing 2." In *The Shape of Things*, 90–95. London: Reaktion, 1999.

Foucault, Michel. *This Is Not a Pipe*. Berkeley: University of California Press, 1983.

Freud, Sigmund. *Beyond the Pleasure Principle and Other Essays*. New York: Penguin, 2007.

Gabbert, Laura, and Justin Schein, dir. *No Impact Man*. Eden Wurmfeld, 2009.

Genette, Gérard. *Mimologics*. Lincoln: University of Nebraska Press, 1995.

Göbel, Volker. Felting Apparatus. U.S. Patent 4,070,738. Filed July 8, 1975. Issued January 31, 1978.

Goodnight Moon . . . and More Great Bedtime Stories. DVD, Scholastic Inc., 2011.

Hanssen, Beatrice. *Walter Benjamin's Other History: Of Stones, Animals, Human Beings, and Angels*. Berkeley: University of California Press, 1998.

Harari, Roberto. *How James Joyce Made His Name: A Reading of the Final Lacan*. New York: Other, 2002.

Harper, H., *Introduction to Textile Chemistry*. London: Macmillan, 1921.

Harris, Jonathan Gil, and, Natasha Korda. *Staged Properties in Early Modern English Drama*. Cambridge: Cambridge University Press, 2006.

Hatherley, Owen. *Militant Modernism*. Ropely: Zero Books, 2008.

Haven, James L., and Charles Hettrick. Whirligig. U.S. Patent 59,745. Issued November 20, 1866.

Hayles, N. Katherine. *How We Became Posthuman*. Chicago: University of Chicago Press, 1999.

Heidegger, Martin. "The Thing." In *Poetry, Language, Thought*, 165–86. New York: HarperCollins, 19771.

Homes, A. H. *The Safety of Objects*. New York: Penguin, 1990.

Hughes, Robert. "The Noise of Beuys." *Time*, November 12, 1979, 89.

Hulse, Michael. "An Occasion for Shrieking?" *Critical Quarterly* 25, no. 3 (1983): 61–65.

Jastrow, Joseph. "The Mind's Eye." *Appleton's Popular Science Monthly* 54 (1899): 299–312.

Jerome, Jerome K. *On the Stage—and Off: The Brief Career of a Would-be Actor*. London: Field and Tuer, 1885.

Johnson, B. S. "Introduction to Aren't You Rather Young to Be Writing Your Memoirs." In *The Novel Today: Contemporary Writers on Modern Fiction*, edited by Malcolm Bradbury, 151–68. Manchester: Manchester University Press, 1977.

Kael, Pauline. *The Citizen Kane Book*. Boston: Bantam, 1974.

Kirk, M. L. *Favorite Rhymes of Mother Goose*. New York: Cupples and Leon Company, 1910.

Knoeplmacher, U. C. "Oscar Wilde at Toad Hall." *The Lion and the Unicorn* 31, no. 1 (2010): 1–16.

Kouidis, Virginia M. "Rediscovering Our Sources: The Poetry of Mina Loy." *boundary 2* 8, no. 3 (1980): 167–88.

Kuenzli, Rudolf E. *Dada and Surrealist Film.* Cambridge, Mass.: MIT Press, 1996.

Kurzweil, Ray. *The Singularity Is Near: When Humans Transcend Biology.* New York: Viking, 2005.

Lacan, Jacques. *The Four Fundamental Concepts of Psycho-Analysis.* New York: Norton, 1988.

————. *The Four Fundamental Concepts of Psychoanalysis.* New York: Norton, 1998.

Lash, Scott. *Another Modernity: A Different Rationality.* Oxford: Wiley-Blackwell, 1999.

Levy, Silvano. *Surrealism: Surrealist Visuality.* Edinburgh: Edinburgh University Press, 1996.

Lewis, Wyndham. *BLAST.* 2 vols. Santa Barbara, Calif.: Black Sparrow, 1981.

Leonard, Anne. *The Story of Stuff.* 2008. http://www.storyofstuff.org.

Little Review 8, no. 1 ("Brancusi Number," Autumn 1921).

Lovett, D. R., K. M. Moulding, and S. Anketell-Jones. "Collisions between Elastic Bodies: Newton's Cradle." *European Journal of Physics* 9, no. 4 (1988): 323–28.

Loy, Mina. *The Lost Lunar Baedeker.* New York: Farrar, Straus and Giroux, 1997.

Luhmann, Niklas. *Observations on Modernity.* Stanford: Stanford University Press, 1998.

Macintyre, Ben. *Operation Mincemeat.* New York: Harmony, 2010.

Mallarmé, Stéphane. *Oeuvres completes.* Paris: Editions Gallimard, 1945.

Mariani, Paul L. *The Broken Tower: A Life of Hart Crane.* New York: Norton, 2000.

Marker, Chris, dir. *La Jetée.* Argos Films, 1962.

Martin, Demetri. *This Is a Book.* New York: Grand Central, 2011.

Marx, Karl. *Selected Writings.* Indianapolis: Hackett, 1994.

Masteller, Richard N. "Using Brancusi: Three Writers, Three Magazines, Three Versions of Modernism." *American Art* 11, no. 1 (1997): 46–67.

Marx, Karl, and Friedrich Engels. *The Marx-Engels Reader.* New York: Norton, 1978.

McCarthy, Tom. *C.* New York: Knopf, 2010.

Mohr, H. Auxiliary Cycle Rest. U.S. Patent 1,357,890. Filed September 3, 1919. Issued November 2, 1920.

Moretti, Franco. *Graphs, Maps and Trees.* London: Verso, 2005.

Motherwell, Robert, *The Dada Painters and Poets: An Anthology.* Cambridge, Mass.: Harvard University Press, 1979.

Murphet, Julian. *Multimedia Modernism.* Cambridge: Cambridge University Press, 2009.

"Nessmuk." *Woodcraft.* 1884, 1920. New York: Dover, 1963.

Newgarden, Mark. *Cheap Laffs: The Art of the Novelty Item.* New York: Harry N. Abrams, 2004.

New York Dada, April 1921.

North, J. D. "The Astrolabe." *Scientific American* 231 (January 1974): 96–106.

Olson, Charles. *The Maximus Poems.* Vol. 3. New York: Grossman, 1975.

Orwell, George. "Politics and the English Language." 1945. In *All Art Is Propaganda*, 270–86. New York: Mariner, 2009.

Palahniuk, Chuck. *Fight Club.* New York: W. W. Norton, 1996.

Penzel, Matthias. *Objekte im Rückspiegel sind oft näher, als man denkt: Die Auto-Biografie.* Freiberg: Orange, 2010.

Poggi, Christine. "Mass, Pack, and Mob." In *Crowds*, edited by Jeffrey T. Schnapp and Matthew Tiews, 191–202. Palo Alto: Stanford University Press, 2006.

Pound, Ezra. "Brancusi." In *Literary Essays of Ezra Pound*, edited by T. S. Eliot, 441–45. New York: New Directions, 1954.

———. "In a Station of the Metro." In *Personae*, 111. New York: New Directions, 1990.

Powers, Richard. *Gain.* New York: Farrar, Straus and Giroux, 1998.

Raine, Craig. *A Martian Sends a Postcard Home.* Oxford: Oxford University Press, 1979.

Rancière, Jacques. "Aesthetics, Inaesthetics, Anti-Aesthetics." In *Think Again: Alain Badiou and the Future of Philosophy*, edited by Peter Hallward, 218–31. New York: Continuum, 2004.

———. *The Future of the Image.* London: Verso, 2007.

———. *The Politics of Aesthetics.* New York: Continuum, 2006.

Read, Leonard E. "I, Pencil: My Family Tree as Told to Leonard E. Read." December 1958. Available at http://www.econlib.org/library/Essays/rdPncl1.html.

Reed, Henry. "Naming of Parts." In *Collected Poems*, 49. Oxford: Oxford Univerity Press, 1991.

Richter, Hans, dir. *Vormittagsspuk*, 1928. Reissued in *Experimental Cinema of the 1920s and 1930s.* Kino International, 2005.

Robbins, Bruce. "Commodity Histories." *PMLA* 20, no. 2 (2005): 454–63.

Robinson, Fred Miller. *The Man in the Bowler Hat: His History and Iconography.* Chapel Hill: University of North Carolina Press, 2011.

Ruskin, John. "Of the Pathetic Fallacy." In *The Genius of John Ruskin: Selections from His Writings*, edited by John D. Rosenberg, 61–72. Charlottesville: University of Virginia Press, 1998.

Sartre, Jean-Paul. "A Fundamental Idea of Husserl's Phenomenology." In *The Phenomenology Reader*, edited by Dermot Moran and Tim Mooney, 382–84. London: Routledge, 2002.

Self, Will. *Junk Mail.* New York: Grove/Atlantic, 2006.

Serres, Michel. *Genesis.* Ann Arbor: University of Michigan Press, 1995.

———. *Hermes: Literature, Science, Philosophy.* Baltimore: Johns Hopkins University Press, 1982.

———. *The Parasite.* Minneapolis: University of Minnesota Press, 2007.

Sheppard, Jean. *The Whole Fun Catalogue of 1929.* New York: Chelsea House, 1979.

Shklovsky, Viktor. "Art as Device." In *Theory of Prose*, 1–14. Normal, Ill.: Dalkey Archive, 1990.

Sloterdijk, Peter. "Rules for the Human Zoo: A Response to the Letter on Humanism." *Environment and Planning D: Society and Space* 27 (2009): 12–28.

Sontag, Susan. *On Photography.* New York: Picador, 1977.

Soule, Gardner. "Fun's Henry Ford Is Still Inventing." *Popular Science,* January 1955, 122–25, 282.

Torczyner, Harry. *Magritte: Ideas and Images.* New York: Harry N. Abrams, 1977.

Trimmer, John D., trans. "The Present Situation in Quantum Mechanics: A Translation of Schrödinger's 'Cat Paradox' Paper." *Proceedings of the American Philosophical Society,* no. 124 (1980): 323–38.

Walkowitz, Rebecca, and Douglas Mao. *Bad Modernisms.* Durham: Duke University Press, 2006.

Walton, Izaak. *The Compleat Angler.* Oxford: Oxford University Press, 2009.

———. "To the Reader of This Discourse." In *The Compleat Angler,* http://ebooks .adelaide.edu.au/w/walton/izaak/compleat/preface3.html.

Weber, Samuel. *Mass Mediauras: Form, Technics, Media.* Stanford: Stanford University Press, 1996.

———. *Theatricality as Medium.* New York: Fordham University Press, 2004.

Wells, H. G. *The Sleeper Awakes.* Lincoln: University of Nebraska Press, 2000.

"When Hard Books Disappear." *The Technium,* http://www.kk.org/thetechnium/ archives/2011/06/when_hard_books.php.

Wilde, Oscar. "Letter to Robert Ross, May–June 1900." In *The Complete Letters of Oscar Wilde,* edited by Merlin Holland and Rupert Hart-Davis, 1187–88. London: Fourth Estate, 2000.

Williams, Raymond. "Culture Is Ordinary." In *Resources of Hope: Culture, Democracy, Socialism,* 3–18. London: Verso, 1989.

Williams, William Carlos. *Kora in Hell: Improvisations.* San Francisco: City Lights, 1962.

Wittgenstein, Ludwig. *Remarks on the Philosophy of Psychology.* Vol. 1. Chicago: University of Chicago Press, 1980.

Wollen, Peter. "Magritte and the Bowler Hat." In *Paris/Manhattan: Writings on Art,* 128–45. London: Verso, 2004.

Zolotow, Maurice. *It Takes All Kinds.* New York: Random House, 1954.

INDEX

Adams, S. S., 67, 70–72, 74, 77, 84
Adorno, Theodor, 18, 135n31
aliens, 27–31
allegory, 36, 54, 62–65, 97, 128
Allen, Woody, 36, 69–70, 72
Andreotti, Margherita, 88
anthropomorphism, 128, 129
Archimedes, 26–27
Armleder, John, 40, 41, 139n15
Arrighi, Giovanni, 136n40
Ashbery, John, 5
astrolabe, Chaucer's treatise on, 5–7,
 134nn13–14
Auden, W. H., 18
Auschwitz, 18, 122
automobiles, 7–8, 38–43, 49

Badiou, Alain, 18, 23, 134n12, 138n67
Bakhtin, Mikhail, 123
Ball, David, 67
Ballard, J. G., 46
Barbie dolls, 24, 128–29
Barthes, Roland, 56, 59, 140n29
Baudelaire, Charles, 5, 23, 75, 80
Bauman, Zygmunt, 105
Beavan, Colin, 93, 98, 106, 108–11
Beck, Ulrich, 23, 94, 103–6, 110, 111,
 136n43

Benda, Julian, 90
Benjamin, Walter, 12, 23, 37–38; and
 Heidegger, 25; on origins, 57–59;
 on parasites, 62, 124–25; on Plato,
 64–65; on props, 52–54, 61–63, 82,
 125; on tragic drama, 54, 57–58,
 61–65, 124–25
Bennett, J. A. W., 134n14
Beuys, Joseph, 23, 112–24, 139n15;
 Felt-TV, 113–14; *How to Explain
 Pictures to a Dead Hare*, 113–15,
 145n155; *I Like America and America
 Likes Me*, 118; *The Pack*, 117, 145n159;
 Queen Bees, 123; *7000 Oaks*, 115–18
Blackwell, Mark, 128
Blanchot, Maurice, 18
books, future of, 27–28, 35, 37, 43,
 138n5
Brancusi, Constantin, 85–88, 143n99
Brower, Steven, 136n33
Brown, Bill, 67, 71, 75, 78, 80
Brown, Margaret Wise, 9, 134n22
Burroughs, William S., 29, 30

Caxton, William, 29
Chaplin, Charlie, 47
Chaucer, Geoffrey, 5–7, 134nn13–14
Chesterton, G. K., 38

155

AARON JAFFE is professor of English at the University of Louisville and the author of *Modernism and the Culture of Celebrity* as well as the coeditor of three essay collections: *The Year's Work in Lebowski Studies*; *Modernist Star Maps: Celebrity, Modernity, Culture*; and *The Year's Work at the Zombie Research Center*.